Timeless Techniques For

BETTER OIL PAINTINGS

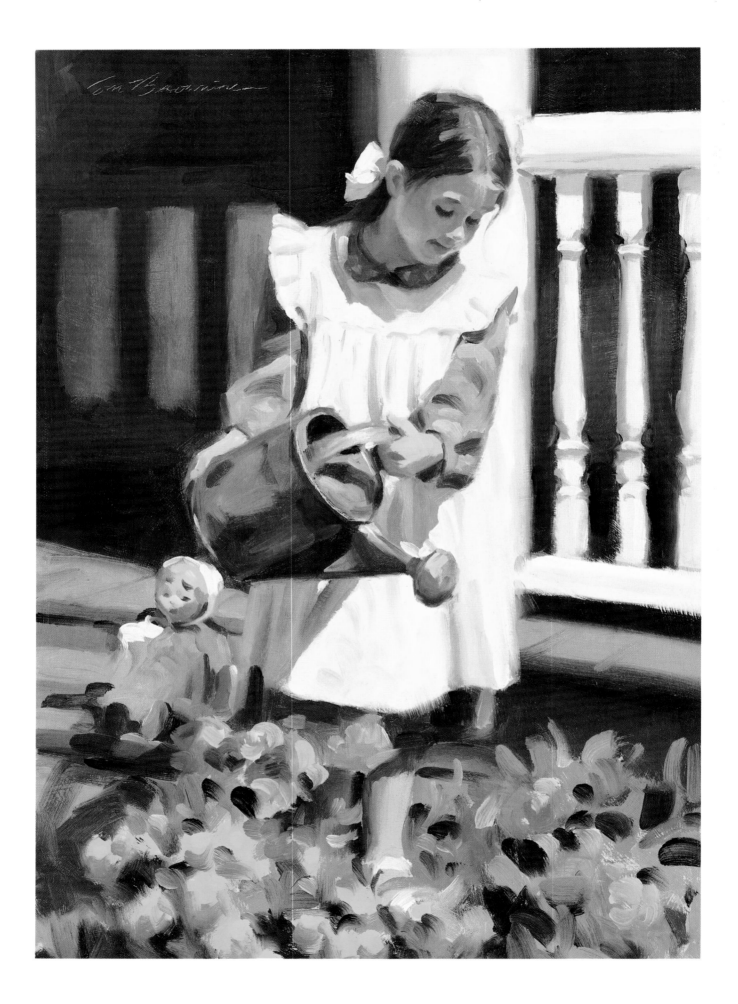

Timeless Techniques For
BETTER OIL PAINTINGS

TOM BROWNING

NORTH LIGHT BOOKS

Cincinnati, Ohio

ABOUT THE AUTHOR

Born in the eastern Oregon town of Ontario in 1949, Tom Browning knew at an early age that he would pursue art as a career. After four years at the University of Oregon, Tom was able to commit all of his time to art. Scratchboard drawings started his professional career, followed by several years devoted to watercolors. Wanting to learn more about oil painting, he began attending workshops and going on painting trips with other artists. He soon realized the absolute necessity of the fundamentals of sound painting that were absent in the contemporary structure of the liberal arts college he attended. Making these fundamentals second nature soon became his goal and, because of its boundless versatility, oil painting quickly became his primary medium.

Tom's paintings have been displayed in numerous national exhibitions including the National Academy of Western Art and the Northwest Rendezvous Group of which he is a member. Tom and his wife, Joyce, also own and operate Arbor Green Publishers, a business devoted to greeting cards.

Timeless Techniques for Better Oil Paintings. Copyright © 1994 by Tom Browning. All rights reserved. No part of this book may be reproduced in any form or by any electronic or mechanical means including information storage and retrieval systems without permission in writing from the publisher, except by a reviewer, who may quote brief passages in a review. Published by North Light Books, an imprint of F&W Publications, Inc., 1507 Dana Avenue, Cincinnati, Ohio 45207. 1-800-289-0963. First edition.

Printed and bound in Hong Kong.

98 97 96 95 94 5 4 3 2 1

Library of Congress Cataloging-in-Publication Data

Browning, Tom
 Timeless techniques for better oil paintings / by Tom Browning. — 1st ed.
 p. cm.
 Includes index.
 ISBN 0-89134-513-2
 1. Painting—Technique. I. Title.
ND1500.B79 1994
751.45—dc20 93-26139
 CIP

Edited by Rachel Wolf
Designed by Brian Roeth

METRIC CONVERSION CHART		
TO CONVERT	**TO**	**MULTIPLY BY**
Inches	Centimeters	2.54
Centimeters	Inches	0.4
Feet	Centimeters	30.5
Centimeters	Feet	0.03
Yards	Meters	0.9
Meters	Yards	1.1
Sq. Inches	Sq. Centimeters	6.45
Sq. Centimeters	Sq. Inches	0.16
Sq. Feet	Sq. Meters	0.09
Sq. Meters	Sq. Feet	10.8
Sq. Yards	Sq. Meters	0.8
Sq. Meters	Sq. Yards	1.2
Pounds	Kilograms	0.45
Kilograms	Pounds	2.2
Ounces	Grams	28.4
Grams	Ounces	0.04

DEDICATION

With appreciation I dedicate this book to my wife, Joyce.

ACKNOWLEDGMENTS

There has been more put into the writing of this book than I would ever have imagined possible. Not only the time and energy spent actually putting it on paper, but the years spent accumulating its contents. I owe a big debt to all of those artists who over the years have generously shared their knowledge so that I might raise my level of ability and strive to do better. I thank artists like Alan Haemer, William F. Reese, Harley Brown, and Delbert Gish for their personal advice and encouragement.

I would also like to thank my editors, Rachel Wolf and Greg Albert, and artist Jan Kunz for bringing North Light Books and myself together. And lastly, a loving word of thanks to my parents for a lifetime of encouragement to do what I love most.

TABLE OF CONTENTS

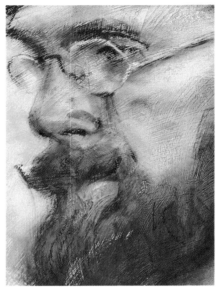

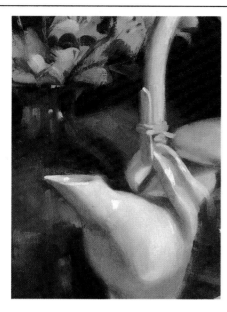
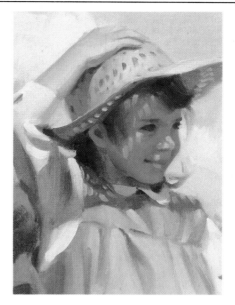

INTRODUCTION

Although there are as many different approaches to painting as there are artists, it's still my conviction that certain principles provide an easier access to successful paintings. These principles are by no means absolute, but if considered by the artist and applied in some way, their application will surely give credence to their usefulness. Understanding these ideas and theories have made the challenge of painting more enjoyable and fulfilling for me, and passing them on to you for use at your discretion is the purpose of this book.

It's a good feeling when I realize my two cents worth of advice has helped a fellow artist solve a painting problem. Whether it's a small technical problem or one of a much larger scope, it's gratifying to know I was able to make a difference. It also makes me realize how much I take for granted each time my brush goes from palette to canvas. As I was writing this book, I was surprised by how much I'd learned over the past twenty-five or more years. Some of this information has become second nature to me while a lot of it is always being considered while I work.

Before I began this project, I knew what elements of painting were most important to me and how much understanding them has meant. There is so much to learn in painting, but knowing a few things *well* seems to make the most difference.

Understanding *values* and *light* is essential for all painters, so I'll cover this subject first. I'll explain how light falls on objects and give helpful hints on how to study and observe the way light models form and creates values.

In chapter two on the topic of *colors*, I'll discuss color temperature and how to neutralize colors in your subject through observation and comparison.

A very important element in any representational painting is *drawing*. Without getting into any actual drawing lessons, I'll show how I view its importance and implement it in my work. My main focus in chapter three is drawing with a brush and gaining confidence in the process.

Views on *composition* in paintings seem to be numerous as well as personal. Chapter four deals with creating and retaining a strong center of interest and the artist's job of controlling the viewer's eye. I'll also demonstrate my procedure in setting up still lifes and scenes involving figures.

The other important elements of painting that I'll cover are *edges* and *brushwork*. In chapter five I'll discuss their relationship to composition as well as the various types of edges I use. I'll also explain how you can use brushwork to help describe your subjects.

Through examples, exercises and demonstrations, I hope to simplify the discussions and clear up any doubts or answer any questions you might have regarding these critical elements of painting. More important, though, I want to provoke thought. One book simply isn't enough to find all the answers to the thousands of questions that have been asked by students of painting. No matter how advanced a painter you might be, and no matter how young or old you are, be like a sponge. Soak up as much knowledge from as many sources as you can for as long as you can. It's important to remain a student all of your life. If you ever reach a point that you're fully satisfied with your painting, you stop growing as an artist. We all have to strive to do better.

But amidst all of the practice and learning, we can't lose sight of the fact that we paint because we enjoy it. Whatever motivates you to paint, have fun.

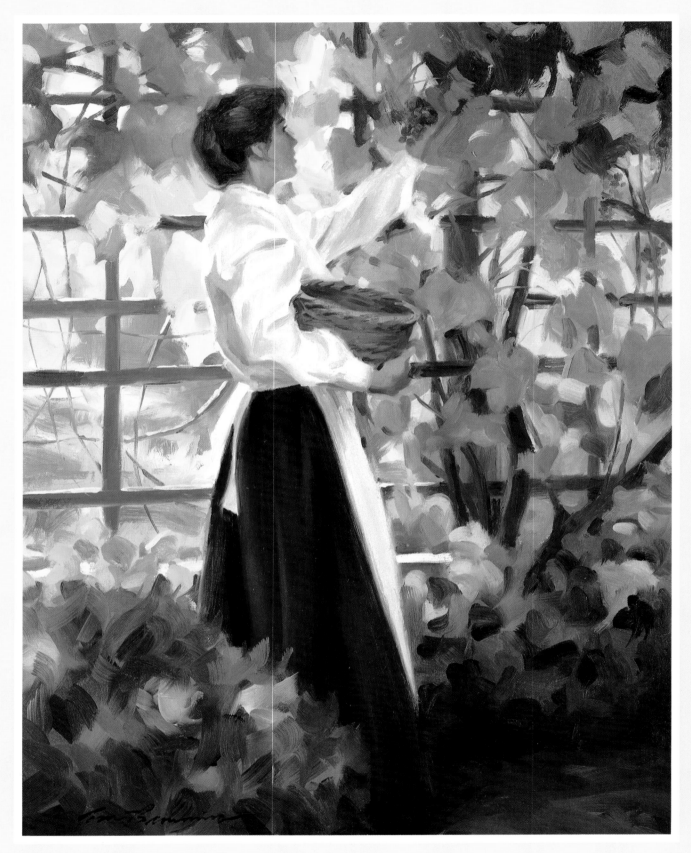

The Grape Arbor, *Oil, 16" × 12"*

UNDERSTANDING LIGHT AND VALUES

I'm starting this book with the element of painting that I consider to be the most important. Understanding values. Their use can make or break a painting. They are a major part of the foundation on which an artist builds a picture. Value control is consistently the number one problem that students and even professional painters seem to have in producing successful paintings.

Even though I feel the concept of understanding light and values is basically simple, I realized while writing this chapter that an entire book could easily be devoted to the subject. So I've tried to simplify and relate how I view the process and apply it each time I paint a picture. I didn't always understand it, but when I began to see how light falls on forms and creates values, painting became much easier. It simply made a lot more sense.

This chapter should help those who feel lost when it comes to values as well as those who are only looking for a few helpful hints. I'll explain how light creates values and how the artist can translate those values into paint, creating the illusion of form and depth on a flat surface. There are exercises for those who want to see for themselves what I've discussed, as well as information and helpful guides for those who want to add to their existing knowledge and understanding of values.

I've always believed that if I go away from an experience having learned only one thing, the time was well spent. So if you are currently having difficulty in this area, taking the time to understand light and values should be worth it.

What Are Values?

Variations in the intensity of light make up light and shade. The word *tone* is often used to refer to a particular variation of light or shade. So a painting, or even a single element of a painting, is made up of tones that are light and tones that are dark. The painting may also include a variation of tones that are somewhere between light and dark.

To simplify this concept, these tones that vary in degree of lightness and darkness are called *values* and can be put on a scale of, say, one to nine — one being the lightest and nine being the darkest. Although these values are in black, white, and shades of gray, value is one of three dimensions of color, the other two being *hue* and *intensity*. There are hundreds of degrees of gray from white to black, but for artistic purposes it's best to limit the

To understand and control values should be your first objective as a painter.

number of values so the change from one to the next is easy to see. These changes, when used in a painting, become *value relationships*.

I'm sure you've seen value scales many times, but as I stated in the intro-

A TYPICAL VALUE SCALE

Although values exist in colors and with a wider range than shown here, with a limited number of gray values it is easier to see value relationships.

duction, I believe values to be the single most important element of a painting. Understanding them is essential. Values must be dark in the right places and light in the right places. And it isn't enough to look at a value scale and say, "That's easy to understand — dark to light and eight variations in between . . . simple." The true test comes with observing an object or a scene, translating its parts into values, and then matching values with paint to create the illusion of a three-dimensional object on a flat surface. This is the essence of painting. To understand and control values should be your first objective as a painter.

To understand values is to understand light, not in an all-encompassing sense, but how light visually affects all that it touches. How it not only reveals the form, but flows over it, disappearing then reappearing. How it seems to gently caress subtle undulations or slam into an abrupt barrier, lighting it up before moving on. Its presence illuminates and creates areas of light while its absence creates defining shadows. So as light travels along, coming into contact with one surface after another, it creates and leaves behind the lights and darks we call values.

1

2

3

4

5

6

7

8

9

Learning to Observe

To understand values we first have to understand how light itself dictates values. Observation is the key to understanding the principles of light falling on a form. Whenever you look at an object, remember, the only reason you can see it and identify it is because light from some source is falling on it. This light not only reveals its overall shape, but also the irregular angles and planes of its surface. Every object or group of objects is unique in the way light falls upon it and changes as the light source changes.

When I started my art career, I worked primarily in pen and ink and scratchboard. Working in black and white forced me to relate everything in terms of values. I usually made sure that my reference was in black and white as well. This made my job of matching values relatively easy. But when I began working in watercolors and oils, I did a lot more painting from life. And I realized the objects in my paintings lacked solidity and convincing form. The reason was that I lacked the knowledge to observe my subject with an understanding of how light reveals form. Not just the overall shape, but all of its irregular surfaces that give it a unique character. When I finally learned to look at the world with this in mind, it was as if someone turned on the light. My work began to improve at a much faster rate.

The first thing to remember when observing light on form is that the surface of an object most perpendicular to the source will appear the lightest (provided the object's surface is not multicolored or of varying values).

As the form of an object turns away from the source of light, darker values appear as shadows. As long as a single light source is used, this obser-

vation usually holds true. It is not a hard-and-fast rule by any means. There are many circumstances that might alter this general rule, but it's still an important one to consider first when observing your subject.

To further understand this idea, take an object in the shape of a cube (such as a white box) and set it on a table under a single light source. Tilt the cube so that one of the surfaces is directly perpendicular to the light. You can see that this is now the lightest-appearing surface on the cube. In other words, this surface is now the

The surface of an object most perpendicular to the source of light will appear the lightest.

lightest in value. Now start turning that surface away from the light. Notice it remains the lightest value until another of the surfaces becomes equally exposed or more perpendicular to the light.

If you now understand how light first falls on an object revealing its form and creating light areas and dark areas, this next exercise will help you to *translate* the values that you see into values you create with paint. And not only will you be seeing value relationships, but you'll also be modeling form.

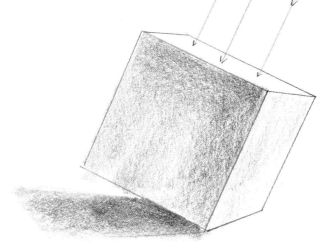

The surface that is most perpendicular to the source of light will be the lightest surface on the form, and therefore the lightest value. The surface that is most turned away from the light will be the darkest, unless it is receiving light from some other source.

Source of light

Translating Values

Take a white box and place it on a table. Position a light (100 watt) about three feet away and at about the same level (as shown below). Turn off any other bright lights in the room. You should be able to see three sides of the box. From now on I will refer to these sides or differing angles as *planes*. Note how the three planes are different in value. One is the lightest value, another is the darkest, and the third plane is a value somewhere between the other two.

With just black-and-white paints try matching values with those of the box before you. First, quickly sketch

in the box on your canvas. Now establish the darkest plane. Mine is somewhere around 7 on the value scale. If you thought about making this plane as dark as say 9 or 10, hold up a brush full of black paint in front of the box. You are now comparing a value made of paint with an existing value on the box. You'll see that the darkest value on the box is far lighter than the black on your brush. In fact, the darkest dark should be a small accenting shadow at the base of the box. Next, paint in the lightest plane. Keep in mind that by establishing the lightest plane, you now have two planes to compare. This makes finding the value of the third plane easy. Once you have painted in the plane with the mid-range value, step back and compare what's on your

canvas with your actual subject.

It's also important at this point to compare the three planes on your canvas. Does the relationship between each of them correspond to the values of the three planes on the actual box? If they don't, simply adjust your paint mixture until it matches what you see before you. These *value relationships* are the key to establishing a convincing form.

Comparison is essential in matching the proper values on your palette with the values on your subject. Remember, this is to develop skills of observation. When doing an actual painting, you may want to make a value darker or lighter than it actually appears if it works better in your particular composition.

Place a bright light about three feet away from a white box, at about the same level.

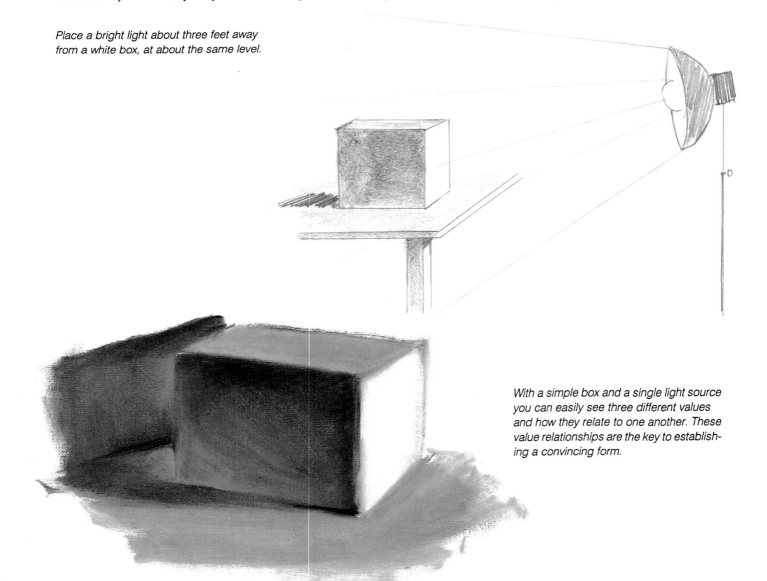

With a simple box and a single light source you can easily see three different values and how they relate to one another. These value relationships are the key to establishing a convincing form.

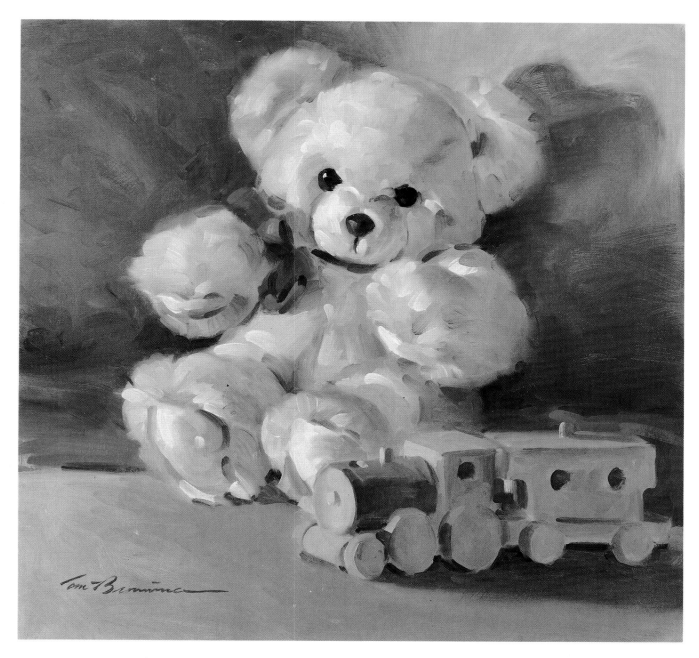

Here's something to remember when making these comparisons. Whenever you look from your painting back to your subject, try doing so quickly. If you stare at your subject too long, value differences become less evident. Your eye operates much like the lens of a camera: The length of time it's open determines how much light is let in. Shadows become lighter the longer you stare, making it more difficult to capture the relationship of light and dark values. I'll be reminding you of this throughout the book. It's important to get used to glancing at your subject in this most important stage of establishing values.

If you followed and completed this exercise, you have just modeled a form. As basic as it seems, observing value relationships and translating values into a modeled form are the sole basis for creating representational art.

Christmas Teddy, *Oil on panel, 15" × 14", Collection of the artist*

I did this little painting several years ago. It was done strictly for practice and pleasure, but I remember very well how the shadowed side of the bear needed to be exaggerated a bit. The contrast from the light side to the dark side was so slight that if I looked too long and hard it seemed to disappear altogether. Glancing quickly at my subject gave me a quick impression by which to establish my value relationships.

Light on Spheres

The planes on a cube are easy to see because of the way light is abruptly diverted by the sharp angles or planes. But on a sphere, the light appears to glide smoothly over the surface until it continues past the object. As a result, the change in values from light to dark is softer and more subtle than on a box.

But let's imagine a sphere that is broken into vertical planes, like the globe at right. Though the angles of the planes are slight, they are still there, resulting in abrupt value change as light passes over the orb. With these planes it's more evident how light falls on a spherical form.

This next exercise in observation is similar to that using the box with the exception that there are no sharp angles to separate values. They flow into one another with a smooth transition that helps to identify the object as a sphere.

Find a round object such as a cue ball, an orange or a baseball. Anything round and of one color will do. Like the box, place it on a table with a single light source. Again, with black-and-white paint and your growing knowledge of values, match with pigment what you see on the table.

Although it has no angles like the box, the ball still has an area of its surface that is perpendicular to the light. This will be the area of lightest value. As the light strikes this spot head on, it appears to disperse itself over and around the form until it passes on to illuminate the table top around the shadow of the sphere.

At the point where the light leaves the sphere you will see the darkest value. This darkest dark usually appears where the light, unable to bend, leaves the surface of the object and the shadow begins. Sometimes called the *core* of the shadow, this dark area pro-

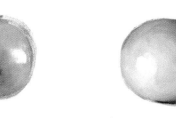

Although the light falls on both of these spheres in the same way, it is easier to see what happens when the surface has actual planes that clearly divert the light. On a smooth surface the change of values is softer and more subtle.

The placement of values on each of these spheres lets the viewer know several things about the objects: Their shape, their general surface texture and, of course, the direction of the light source.

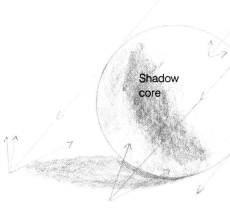

Original light source

Shadow core

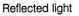

Reflected light

Light that bounces off the reflective surface of the table top becomes reflected light. This secondary source of light then lights up the underside of the ball. If the ball were sitting on black velvet, the light would be absorbed, and reflected light would not exist.

gressively gives way to lighter values as the shadowed plane picks up light from surrounding sources. This could be considered the end of the shadow. Note that although the shadowed side of the sphere in the sketch at left consists of one-half of the sphere, the outer edges of this shadow become lighter in value. This *reflected light* comes from the table surface as well as light bouncing off the background surfaces.

Reflected light is important to detect and add to your painting. It not only helps to identify the shape of an object, but also adds realism. Reflected light describes the way light falls over an object and bounces back into it. If it's actually there, it's best to put it in. Reflected light can keep a rounded surface from looking flat as well as adding interest and excitement.

Lillian, *Oil on panel, 14" × 11"*

The girl's face in this pose is completely turned away from the source of light. However, the sunlight bounces off the white of her lap and illuminates the underside of her face with a warm glow. Even the column behind her is receiving reflected light from her back.

I suggest you move the light and repeat this exercise a few times to further strengthen your observation abilities. Then try putting a dark background behind the subject, not letting any light fall on the background so it will be as dark as possible. Note how your job of comparing values has changed with this new *contrast*. It also creates a stronger visual impact, which I'll deal with at length later.

Again, match the values and be sure to include the background. When you've finished, move the light and repeat the procedure. Don't spend a lot of time on this unless your time is spent repeating the exercise over and over. I would say ten to fifteen minutes for each one should be a good time limit to consider. Although it might seem tedious, this will shorten your painting time in the long run. You'll be able to observe, match values, and establish your overall painting quickly and more accurately. When comparing, remember to glance at your subject rather than stare. There are times when looking long and hard at your subject is necessary, but not for comparing values. Trust me.

Light on Multiple Planes

Students often get confused by objects that have a multiple-plane surface, such as the human head. Although the head is basically considered a sphere or even a cube, its bumps, dips and varying features create a wide array of shapes and values that can be more confusing. The thing to remember is your light source and how it affects not a nose, but a form rising up from a spherical object. To simplify this idea,

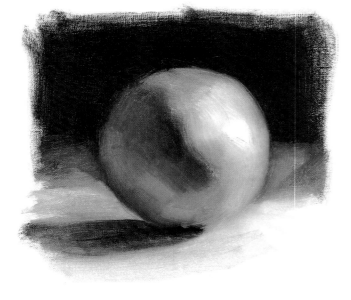

By adding a dark background, seeing values and translating them is actually easier because of the contrast that is created.

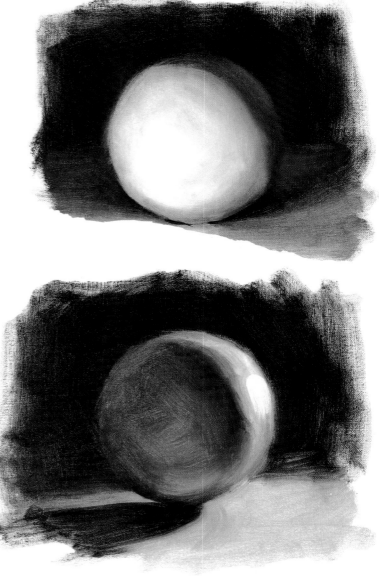

let's return to the basic cube.

Take two boxes of the same color and stack one on top of the other so they are *not* aligned. Give them a single light source and observe how each of the planes you see is a different value. Now, instead of having three values as with one cube, you have an additional two. The tops of both boxes should be the same value since they are receiving the same light from the same angle.

When painting your planes, remember to look for the subtle changes in values, such as reflected light and shadow cores. And remember to compare the planes on your canvas with each other as well as with those on your subject. Think of your shadows as having a beginning and an end.

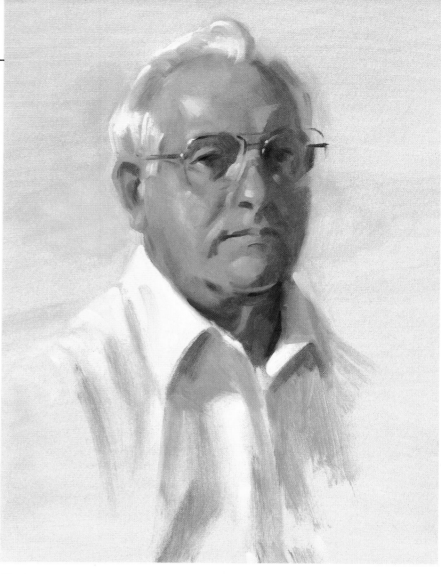

Charley

The human head can be compared to a basic sphere or cube. With a single light source, all of its planes, bumps and dips are revealed, making it a little more complex. But remember that each feature is simply another form, and each change in value is relative to the light.

The more angles that exist on an object, the more values you will see.

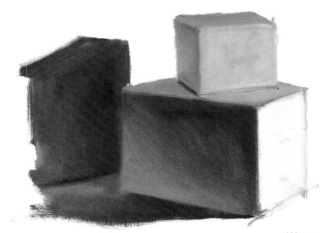

(Below.) The light falling on the individual bumps and dips dictates the changes in values. By adding these few values, the subtle variations in the surface appear. With this solid foundation of form, more detail can be added or it can be left alone. Either way, the viewer knows exactly what he's looking at.

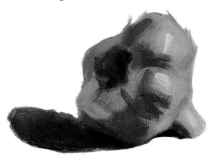

(Above.) This simple shape is not much different than a cube or a sphere. With two values only, I establish the dark side and the light side. The darker value in the center is then added.

Up to now I've been using light-colored objects. What happens when dark colors are put under the same light? All of the values are scaled down, but the relationships of the planes will be the same. Compare the sketch of the garlic with the portrait of Charley on the previous page. The lightest plane in the garlic is also the lightest plane in the portrait head. The same applies to the darkest planes.

The principle is the same no matter what the color or shade of your subject. The light source will always dictate the lightest values and the darkest values. If you're in a position to control your light source as well as your subject, you can accurately create just about any effect you desire. That's one of the reasons I enjoy painting still lifes so much.

Whether an object is dark in overall tone, or light, the value relationships will be equal under the same light source.

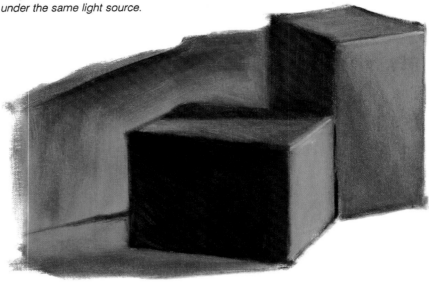

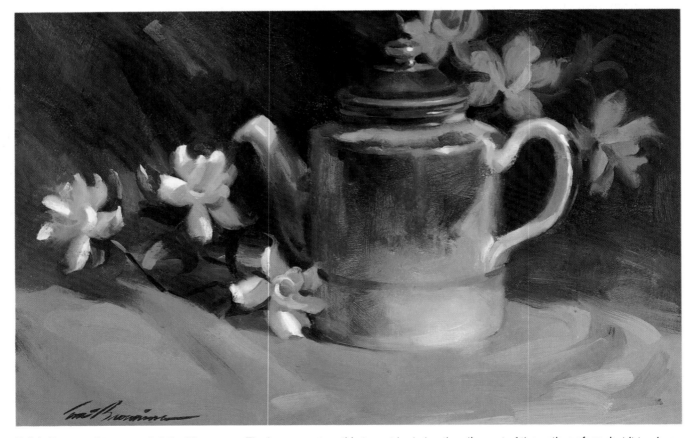

Tolly's Teapot, *Oil on panel, 14" × 9"*

The brown spot on this teapot is darker than the rest of the pot's surface, but it too has to register a value on the light side as well as the shadowed side. So as the teapot turns into the shadow, the brown spot grows darker in unison with its surrounding colors.

Keeping Values Simple

When a painter is learning to observe and translate values, it is important to keep values simple. Although later I'll deal more with simplifying values as they relate to composition and design, I'd like to point out the need to simplify values on individual objects as well. So far, we've determined that when light falls on an object revealing its form, the values tell the viewer about the object. When translating to paint, simplicity can sometimes best convey to the viewer what the artist sees.

When too many values are painted into a particular plane of a surface, that plane loses its identity. It's like adding pieces from one jigsaw puzzle to a different puzzle. Not only do too many values become distracting, but they also break up the flow of light so that the painted surface is more difficult to identify. This problem is best curbed while observing. As I mentioned before, glancing at your subject is one way to experience and visualize a strong impression. This not only helps to compare values and color, but also to minimize detail. More important than minimizing detail, however, is simplifying values. The best way to reduce the values in what you see is by squinting your eyes, thus letting less light affect what you see.

Look around you and focus your eyes on some object. Then squint your eyes and notice how some values dissolve right into those surrounding values. They seem to disappear while other values strengthen. This is the first step in simplifying values, and is essential to making a strong statement with paint. When a nice solid shadow is broken up by strokes of paint that are too light, the shadow loses its strength and importance.

A Pause in the Garden, *Oil on panel, 9" × 12"*

I didn't want this small study to be overburdened with detail. Instead, an effect of sunlight and mood were my intentions. By simplifying forms with a limited range of values, I was able to focus on my goal.

When searching for values on any form, try to remember: The shadowed side should not contain any value as light as the darkest value on the lighted side. And likewise, the lighted side should not contain any value as dark as the lightest value of the shadowed side.

I know that sounds confusing, but go over it until it makes sense to you. It's really not a lot to remember. It's not a rule that can be taken too literally, but does provide a check system that will help maintain a strong balance of values. There must be a dark side and a light side. Once the values of these two sides become too similar, the form is lost, and a weak and undesirable effect prevails. This is not to say that variations of values in a stated plane don't exist or should never be added. If they are added, their differences should be kept subtle. With experience you'll be able to tell when a mass or plane is breaking up with too many values. Just remember to squint while looking at your subject. If you don't currently practice this simple form of observation, you should start now. I can almost guarantee an improvement in your work.

The shadowed side should not contain any value as light as the darkest value on the lighted side. And likewise, the lighted side should not contain any value as dark as the lightest value of the shadowed side.

Up until now, I've been using black and white to help illustrate my points concerning values. Values do indeed appear in colors, but they're a little more deceiving than black and white. My intent is to help set a solid foundation for any painters who lack a good understanding of values and their importance. Observing values in color is done the same way as in black and white. If you do have a problem identifying values while you paint, try a quick oil sketch in black and white to help solve your problems. A small value sketch can also be a good preliminary exercise before starting the actual painting. Even a pencil sketch to reveal value patterns is a good idea. Many painters and illustrators never start a painting until they've done a value study to help guide them. It's good advice, and admittedly, I've paid the price many times for not planning better.

WRONG

An object with a reflective surface can be troublesome because it picks up values that exist around it. A mistake lots of painters make is adding too many values to a mass. If any values in a shadow are too light, this breaks up the mass and confuses the information received by the viewer.

RIGHT

By keeping values closer together in the shadowed side, the object holds together and lets the viewer enjoy a simplified version of a complicated object. Even though lighter values may actually appear in the shadowed side of the subject, it's the job of the artist to control the values and not let a broken surface confuse the viewer. Hold those masses together and simplify!

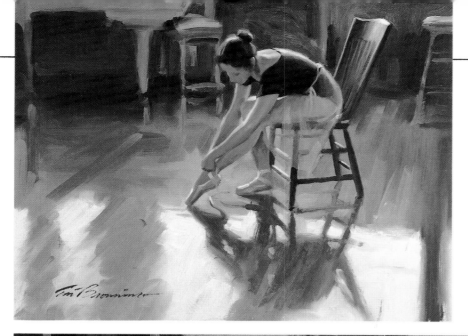

Morning Rehearsal Study, *Oil on panel, 9" × 12"*

(Left.) The values used on the floor in this painting tell the viewer that the floor itself has a reflective quality. The patterns of a window that exists outside of the picture are light in value. Aside from the shadow of the seated figure, these values remain uncontaminated by any dark values that would break up the mass. Even though the actual floor was reflecting light spots in the darker areas, I wanted to simplify the masses by eliminating such light spots and keeping all of the values fairly close together.

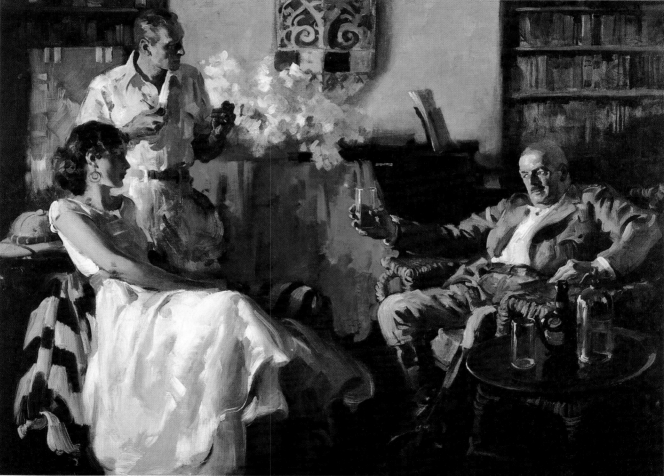

Door of Opportunity, *Haddon Sundblom, Oil on canvas, 29" × 40"*

(Above.) I'm lucky to have such a fine example of value relationships in my collection. Even though it's primarily a black-and-white painting, it's loaded with information. Look closely at how the light enters from the left and flows over the woman's dress. Each of the figures present a solid form made up of a light side, a dark side and simplified masses.

Magazines from the 1920s and '30s are filled with such illustrations. Color printing hadn't yet been economically perfected, so illustrators were asked to do their work in black and white. Sometimes one other color such as blue or red was added. If you have a library near you that still has bound volumes from this time period, it's well worth going through them and studying how some of the great illustrators handled light on forms.

DEMONSTRATION
Controlling Light and Values

Before delving into color too deeply, I'd like to summarize what I've discussed to this point about light and values by way of a simple demonstration. I've chosen a subject that has a limited range of color, so I'll take advantage of a limited palette. In the next chapter I'll discuss the other two dimensions of color (hue and intensity) and incorporate them with values to show how they all relate to one another.

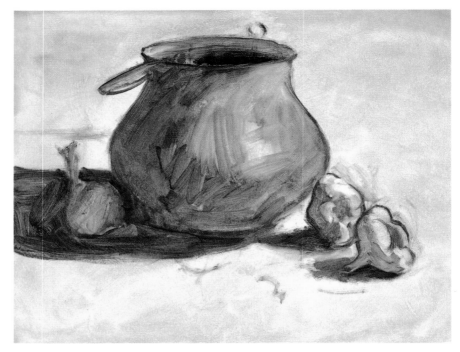

Step 1

In this first step I began to establish the basic components of the composition and a rough idea of value relationships. After toning the canvas with a thin wash of ivory black and yellow ochre, I sketched in the placement of the objects. Then with a mixture of viridian green and cadmium red I established the forms of the objects by painting in the shadowed side of each object and the shadow it cast. These value patterns represent the skeletal structure of the painting.

Step 2

Before doing any more work on the objects themselves, I wanted to develop more value relationships to use for comparison. So I painted in an approximate value to represent the background using a thin wash of ivory black, yellow ochre and viridian green. I then quickly covered the foreground with a thin wash of yellow ochre and cadmium red. Although I knew that most of these values would be painted over and adjusted, I now had a basis for comparison on my canvas. I could begin to bring the picture up to its proper values by comparing one area with surrounding areas.

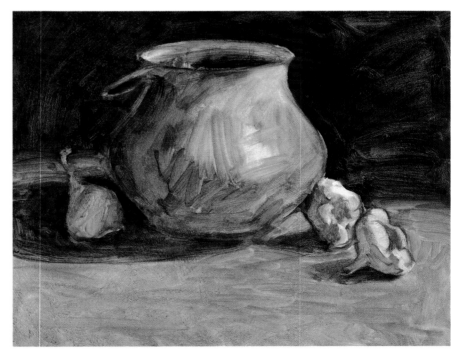

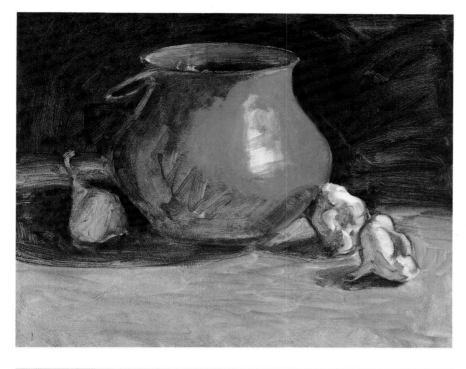

Step 3

At this point I began to define the lighted area of the copper kettle. I could have begun just as easily with the shadowed area, but I wanted to get a suggestion of color into the picture. With mixtures of viridian green, yellow ochre, cadmium red and titanium white, I painted in the area of the kettle that was receiving light.

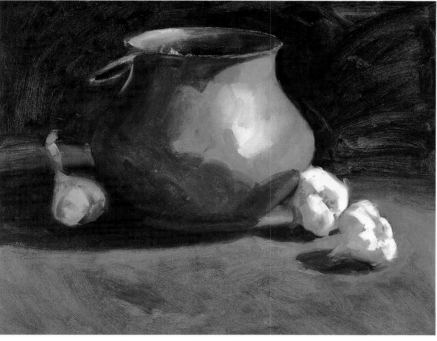

Step 4

Using ivory black, viridian green and yellow ochre, I went back into the shadowed side of the kettle to establish a more accurate value relationship with the lighted side. I then worked on the garlic with the same approach as the kettle. I painted on the light sides, then adjusted the values of the shadowed sides. Then with a little thicker paint than the original wash, I adjusted color and value in the foreground.

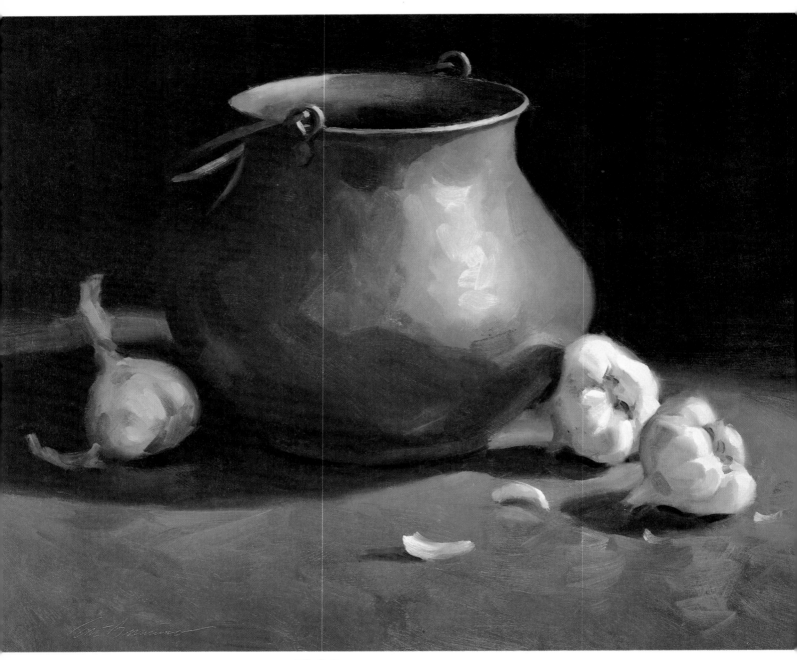

Copper Kettle, *Oil on panel, 14" × 18"*

Finish

At this point I stepped back and saw that most of the hard work had been done. All that was left was refining edges, finishing detail, and adjusting color and value. This pulling-together process is what gave the painting a more finished look.

The background needed a darker, richer look, so with ivory black, viridian, and yellow ochre I darkened it to give the kettle more prominence. Details such as the hooks and handle were added, and more color was put into the lighted side of the kettle. Although the shadowed side of the kettle was picking up a lot of reflections from around the room, I chose to eliminate those and keep the values relatively close together. A suggestion of reflections on the table top and a few pieces of garlic skin completed the picture.

A Four-Step Summary to Seeing Values

There's a lot to remember about how to observe value relationships, and how to translate the values into a modeled form. Eventually it becomes second nature, and once it does, painting whatever you want becomes much easier. Here are some helpful hints to keep in mind while you are learning to control values and light.

1. Use a single source of light.

Try to stick with one light source on your subject. If you have more than one for a desired effect, be sure that one dominates over the other. Too often I see struggling students referring to photographs that have been taken under multiple light sources, but trying to paint as if there were only one. They become lost and confused because the values in their reference are not correct for having one light source. Unless they fully understand how light falls on the form they're trying to paint, their values will not be correct. Therefore, their forms will not be convincing. And remember, the surface most perpendicular to the source of light will have the lightest value.

2. Always compare.

From the very beginning to the final stroke on your painting you must constantly compare values and their relationships with surrounding values. After a few strokes of the brush, step back and compare the color and values on your painting with those of your subject. Try glancing at your subject then quickly looking back at your painting to make this comparison. This is the quickest way to see whether or not you are headed in the right direction.

3. Squint your eyes.

Although I've suggested glancing at your subject quickly for the impact of a first impression, observation does take care and a little analyzing. Another way to reduce the amount of light into your eyes is to squint your eyes down to tiny slits. This reduces all the details in your subject, letting them dissolve into the main masses that you should be most interested in capturing at the beginning. When you want to add more detail, just open your eyes a little wider and they will be there for you.

4. Simplify masses.

Many paintings are ruined with unnecessary detail that could have just as easily been left out. Details are fine, but take care that they don't break apart the masses or patterns that are needed to let a painting look as strong from fifty feet away as it does from five feet. Remember to keep the values in a single mass close together and to a minimum.

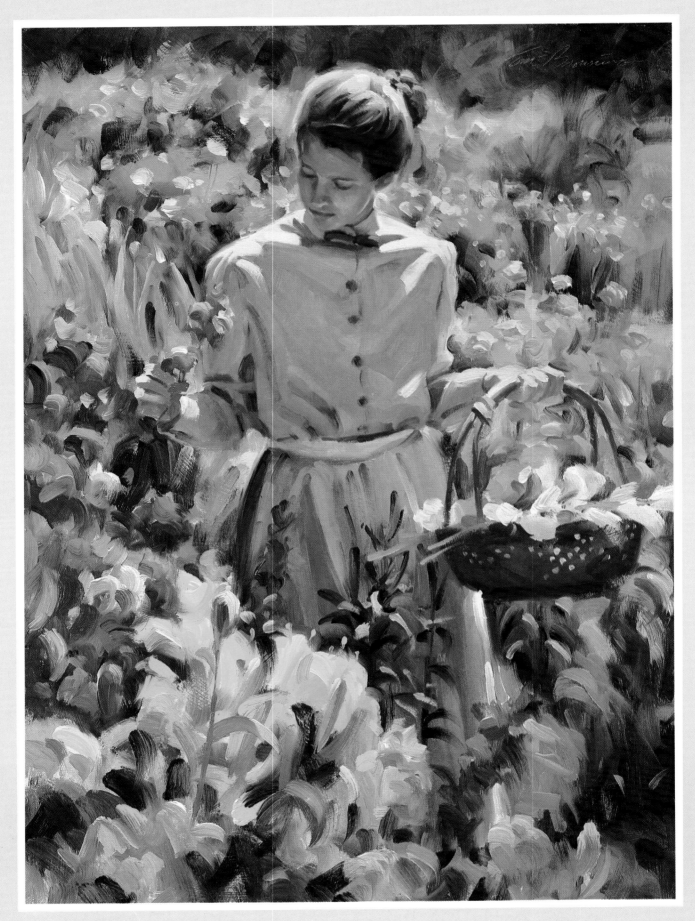

Amy's Garden, *Oil on panel, 18"×14"*

COLORS AND THEIR EFFECTS

As with any subject, the study of color can be as scientific or as complicated as one wants to make it. When discussing light in the previous chapter it was not my intention to delve into the physics of light, but to concentrate on how to observe its effects on objects from an artist's perspective. Likewise, I'll discuss color and its principles at a level that the artist can easily understand and apply.

There has been plenty written on the theory of color that explains the spectrum, color rays, light waves that produce color, and so on. It can be interesting reading and it doesn't hurt to have a little background in the physics of light and color. However, seeing how light affects color and applying that knowledge to the mixing of paint is a lot more practical and fun for the artist.

Values in Color

We know that every color has a value. Somewhere on the value scale is a degree of darkness that equals every color. As I've stated before, I believe values to be the most important aspect of color in particular and painting as a whole. Therefore, it's imperative while painting to be able to observe a color in your subject and translate its value into paint. As I demonstrated in the first chapter, *comparison* is the key to solving any questions you have about the value of a color—that is, comparing the value relationships of your subject to the value relationships in your painting. Observation and practice are the two things that will help the most.

Hue and Intensity

Hue and intensity provide the artist and viewer the pleasure of color and mood. Without hue and intensity, our paintings would be black and white and composed of values, but no color. And it's important to remember that I might see color differently than you or the next person. Our eyes and minds don't necessarily process color in exactly the same way. But if the values in a painting are correct, then colors are allowed to vary with the artist's discretion and still register as convincing and natural.

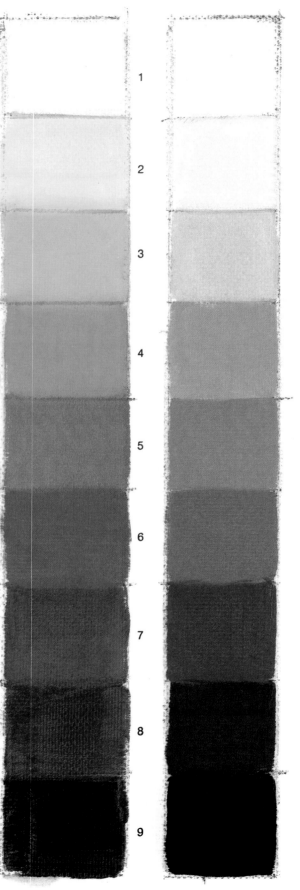

(Left.) Every color and degree of color has a value that corresponds to a placement on the black-and-white value scale. Here the color cadmium vermilion (no. 5) progresses from its darkest value to its lightest tint.

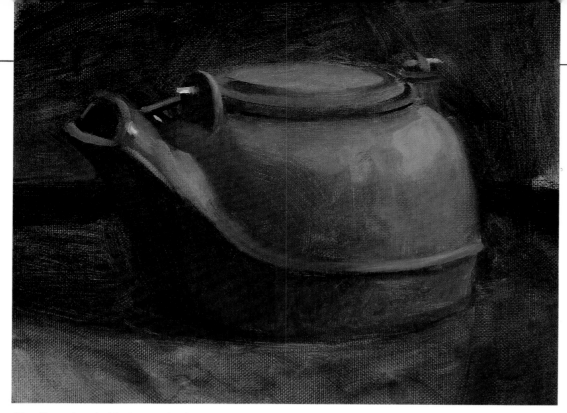

Here I've painted a black stove kettle with black-and-white paint to demonstrate how cold and lifeless such an object might be seen.

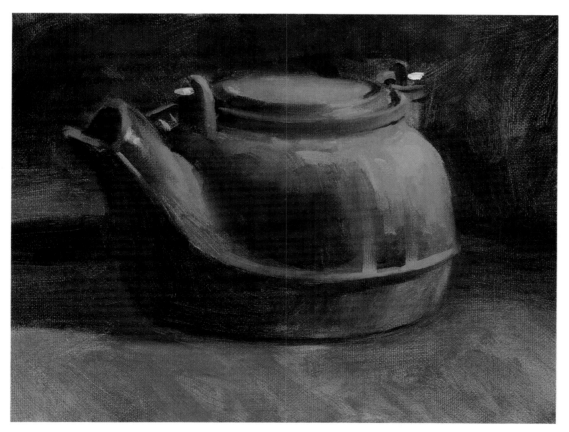

The same object painted in color reveals a lot more of its character, such as rust and age. I could carry it even further with observations of subtle color changes and capture even more of its beautiful qualities.

The word *color* is so all-encompassing that the word itself can easily be taken to mean one thing while in fact its use might be intended in another way. So the term *hue* is used to describe color in more specific terms. Most artists seem to interchange the words hue and color all the time. The terms usually refer to the same thing. Hue is simply a more precise word when you want to be more specific about color. When you combine cobalt blue with yellow, you get green. But when you alter the ratios and maybe add a touch of white, you create a tinted hue that can be much more interesting. By adding more yellow or more blue, you are altering the hue, though the color is still green. If you add more white to the mixture you are changing its value, but not its hue.

For example, let's look at a green pepper. It has a local color of green and, depending on the light falling on the pepper, some areas of green can be warm while others can be cool. Some spots might have more yellow while another area can take on more red. These variations of the local color green are hues that carry a lot of importance in making a painted object or scene more convincing.

Although the local color of these peppers is green, I use various green hues to help describe their shapes, character, and what kind of light is falling on them.

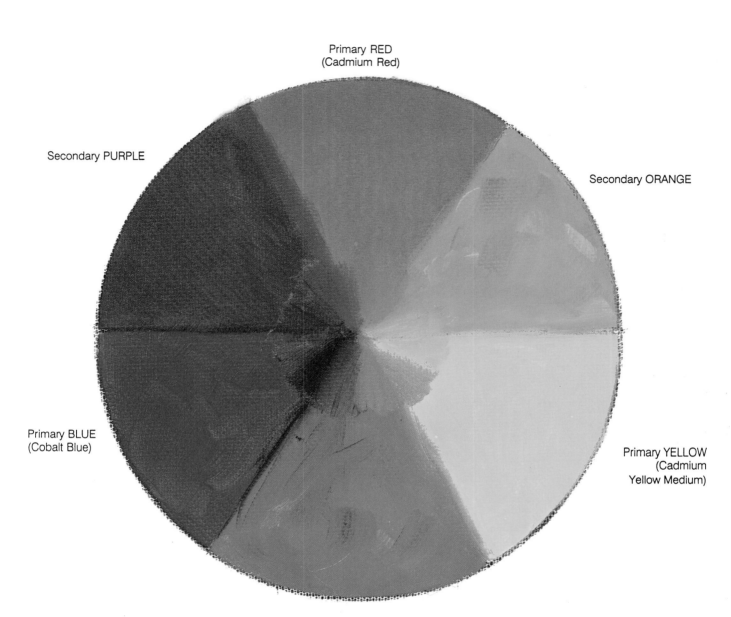

Primary RED
(Cadmium Red)

Secondary PURPLE

Secondary ORANGE

Primary BLUE
(Cobalt Blue)

Primary YELLOW
(Cadmium
Yellow Medium)

Secondary GREEN

Before discussing the third dimension of color, I think some students would benefit from making up a color wheel to pin up near the easel for reference when mixing colors. I made one up years ago and found it extremely useful. Although I no longer have the color wheel, its mental image is just as useful.

Even though an incredible array of colors is available in tubes, it's important to know how to mix any color you see from the few you have on your palette. "Or come close" should be

added to that thought, I suppose.

The three colors that cannot be made from any mixtures are the three primary colors: red, yellow and blue. Secondary colors are made by mixing any two of the primaries together. So orange, green and purple make up the list of secondary colors. By combining a secondary color with the primary next to it on the color wheel, a tertiary color is made. The tertiaries are red-orange, yellow-orange, yellow-green, blue-green, blue-purple and red-purple.

Here's a basic color wheel showing the primary and secondary colors. In the center portion of the wheel each primary has been mixed with the adjacent secondary color. This creates the tertiary colors. Complementary colors are those that are opposite each other on the wheel.

You must be able to alter the intensity of a color to create harmony in your paintings.

From the tertiary colors you can go on to mix quaternary colors and so on. But for practical purposes, tertiary colors are an adequate extent of a simple color wheel. As with most artists, my color mixing has become second nature, but I do frequently recall the mental image I have of the color wheel and use it, particularly when mixing grays.

The third dimension of any color is its *intensity* — that is, its strength, brightness or purity. Intensity can be better understood when compared to values and the value scale. On a value scale, pure white is on one end while pure black is on the other. Graduating tones of gray exist in the middle. Usu-

ally the most intense state of a color is somewhere in the middle of the value scale. When you mix the pure color with white, or even a touch of another lighter color, the intensity decreases into a lighter *tint*. When the pure color is darkened, the intensity decreases into a *shade*.

When you lighten or darken a color you are most likely affecting its value and intensity. Yellow is the lightest of colors when at its most intense state, while purple is quite dark at its most intense. The importance of knowing how to properly read a color's intensity is simple. You must be able to alter the intensity of a color to create harmony in your paintings.

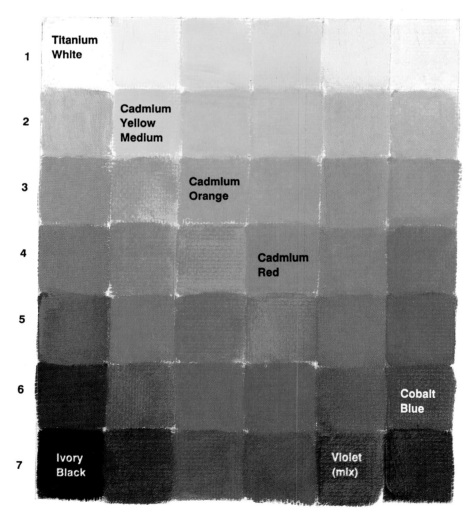

INTENSITY SCALE

This scale shows the relationship of a color's intensities and its values. Pure yellow is most intense at a higher value than is orange, while a very intense blue is much darker in value than a pure red. Note also that the warmer colors are lighter in value when most intense than the cooler colors, which are darker in value.

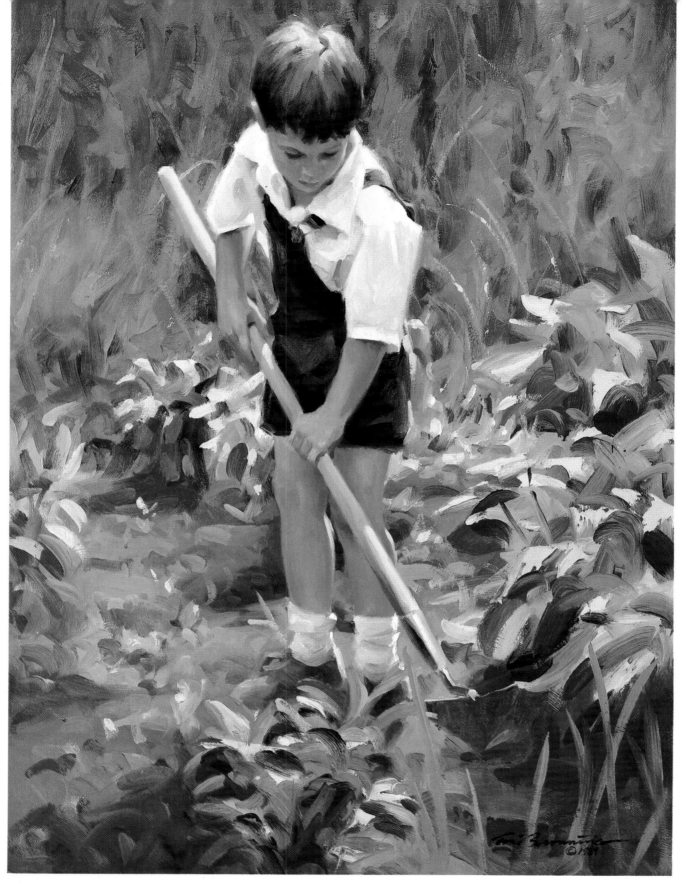

Gentleman Farmer, *Oil, 16" × 12"*

The blue of the boy's coveralls is a little too dark and intense to harmonize with the other colors in the painting. A little more green added to the blue would have helped.

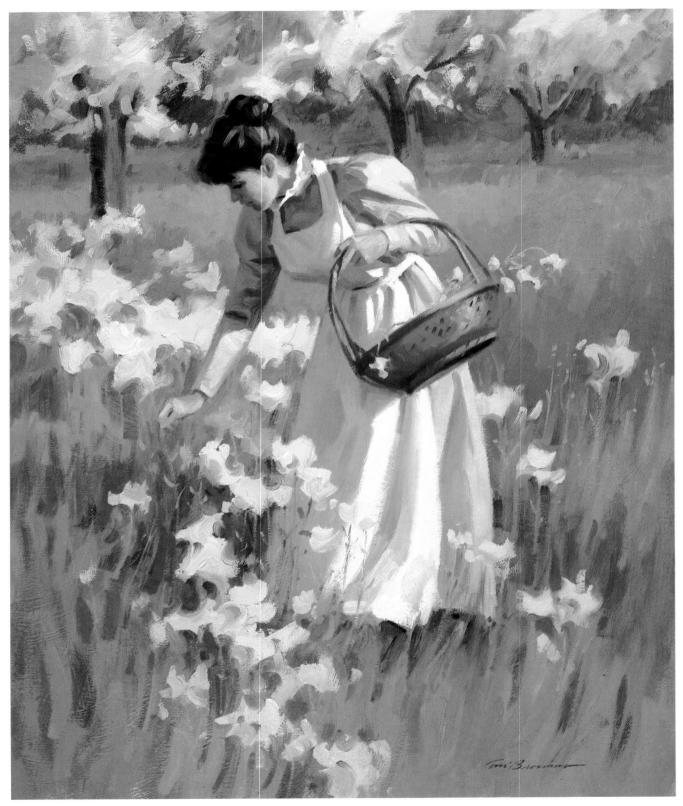

Orchard in Bloom, *Oil, 24" × 20"*

The majority of colors in this painting all come from the same area of the color wheel, mainly yellow and green. Although I used other colors throughout the picture, I altered them with yellows and greens to put all the colors in close harmony.

It's also important to know how to change the intensity of a color without changing its value. Or maybe change a hue without sacrificing intensity. Hues, values and intensities are all relevant to the situation or subject matter being painted. They are all related, but you must think about them individually so you can alter any one or all three at your discretion. And remember: As with values, hues and intensities are affected by the type of light falling on the subject.

As with values, hues and intensities are affected by the type of light falling on the subject.

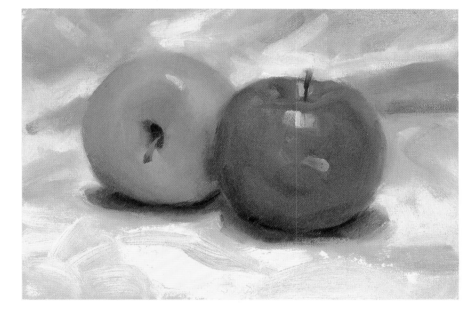

This lighting situation results in a warm background and little shadow on the apples. Changes in hues and values are somewhat subtle.

By changing the lighting on the apples, a cooler background was created, while values and hues are in much more contrast. Try setting a simple object out and quickly painting it. Then change the lighting on it and paint it again. The more times you change the lighting and paint the object, the more accustomed you'll become to finding the values, hues and intensities of colors.

Mixing Neutrals

When the paint mixtures on my palette or on my canvas are simply too intense for the subject I'm painting, it becomes necessary to neutralize or gray those colors so that they better suit the scene. One way to decrease the intensity of a color is by adding to it a bit of its *complementary color*. Refer back to the color wheel on page 25 for a moment and pick a color: green, for example. Opposite of green is red. Red is the complement to green, and likewise, green is red's complement. They are opposites.

By mixing a touch of red into green, the intensity is reduced and it becomes a more neutral or *grayed green*. At a less pure state it is also easier to harmonize with other colors in the painting. This neutralizing of colors can produce some beautiful grays. Keep in mind that complementary colors do not need to be mixed in equal proportions to achieve a neutral gray. Orange and blue in fairly equal proportions produce a nice gray; however, very little yellow is needed to neutralize purple. And a one to three ratio of

When you mix colors, you are most likely changing hues, values and intensities at the same time.

a red and green mix gives us a neutralized color. Remember that when you mix colors, you are most likely changing hues, values and intensities at the same time.

Here I've taken a few intense colors and decreased their purity by adding a bit of their complementary colors. The results are more neutral variations of the original color. Notice how they're also more harmonious.

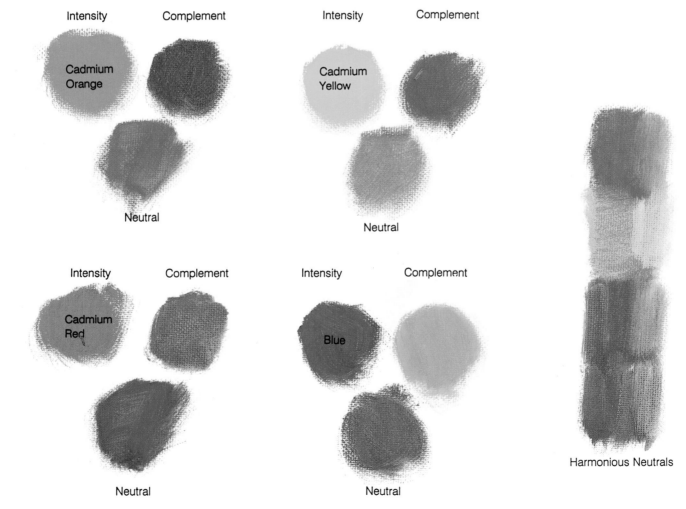

Harmonious Neutrals

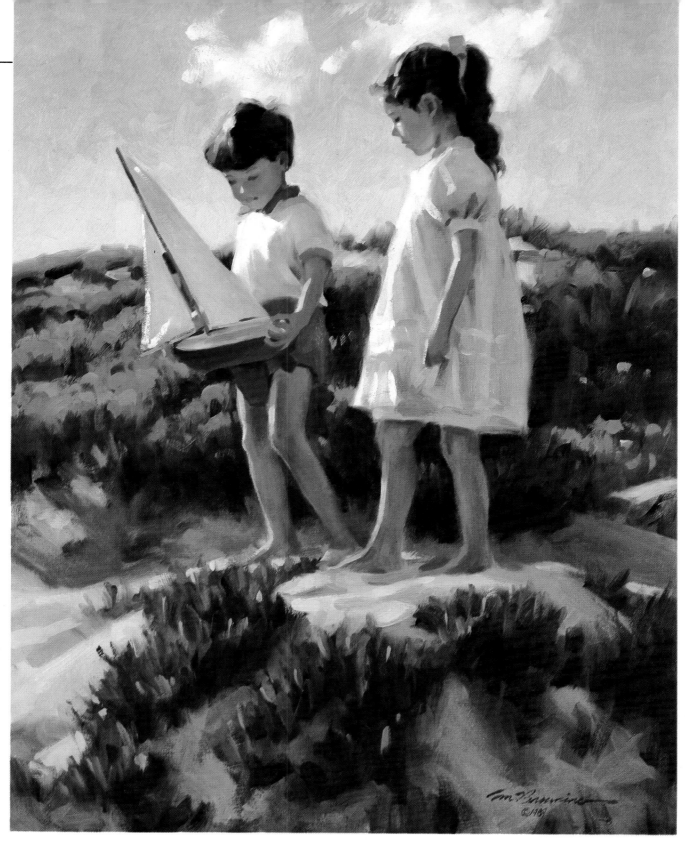

Maiden Voyage, *Oil, 18" × 14"*

Notice how the greenery behind the children differs from the green plants in the foreground. I used red to neutralize the greens in the background, mixing the colors on my palette. The greens in the foreground contain what appears to be more red, but they're not as neutral. I didn't mix these reds into the greens, but let them stand out against the greens. This leaves the green plants more intense in color, but still complements the red.

When I want to make a color such as yellow a darker value, say to indicate that it's in shadow, its complementary color is a good place to start. Mixing black with yellow would result in a dirty green hue. But by mixing a bit of purple into yellow, a nice shade of yellow is produced. The intensity and the value are both lowered. The more pur- ple added, the darker the yellow becomes. Try mixing complementary colors on a blank canvas and experiment with different ratios. It's amazing how many different values, hues and intensities you can achieve with two colors. A little white makes them appear even more neutral and varied.

Using black to darken yellow creates an undesirable green. However, mixing yellow with it's complement, purple, gives a better impression of yellow becoming darker. The other swatches are examples of possible ways to darken colors.

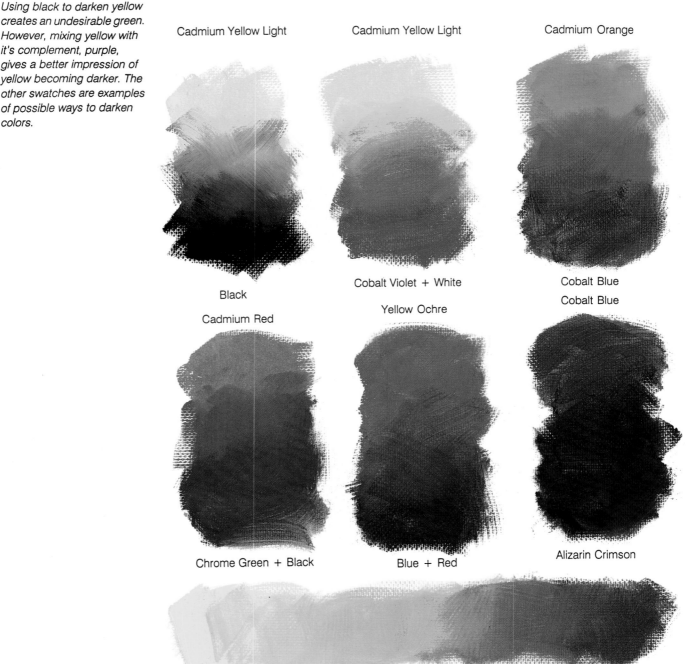

Cadmium Yellow Light Cadmium Yellow Light Cadmium Orange

Black Cobalt Violet + White Cobalt Blue
Cobalt Blue

Yellow Ochre

Cadmium Red

Chrome Green + Black Blue + Red Alizarin Crimson

Cadmium Yellow Light Cobalt Violet + White

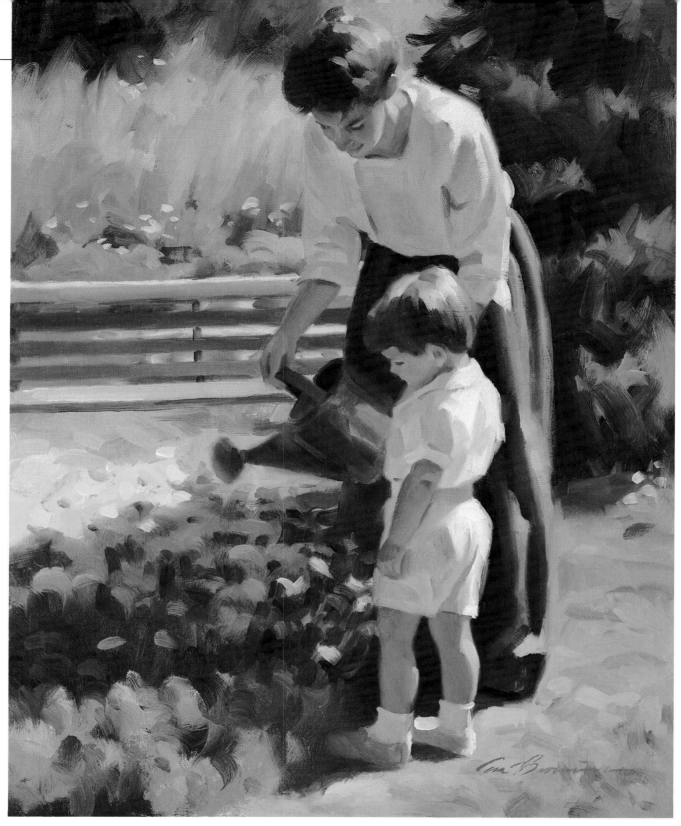

Tending the Garden, *Oil, 14" × 11"*

I wanted the yellow flowers in the foreground to emerge from the shadows into the sunlight. I used a purple mix with ochres to darken the yellows in the shadow, then let this mixture blend into the greens. The flowers in the sunlight are pure yellow and white.

Mixing Colors

There are several ways I mix my colors. Sometimes I prefer to mix colors on the palette using a knife or brush, while other times I like mixing pigment directly on the canvas. Another and perhaps more interesting approach is letting colors mix visually by placing them next to each other on the canvas.

Obviously, one color affects another. Directly mixing two colors will certainly result in a different color. But by simply being next to each other, colors can also have an obvious visual effect. The easiest way to observe this is by placing blue spots of color next to yellow spots of color. When you stand back, they tend to visually mix together, forming green. This technique was used by many of the French Impressionists. Another interesting exercise is to make several swatches of the same color, say a neutral gray/red. When the swatches become surrounded by different grays of different hues, they tend to take on different hues themselves. They may also appear to be of different values. As you can see below, it appears that the center swatches are of different mixes of paint, when in fact they are all identical. This example of visual mixing might be the artist's intention, or it might be involuntary, but you should always be aware of the effects you are creating.

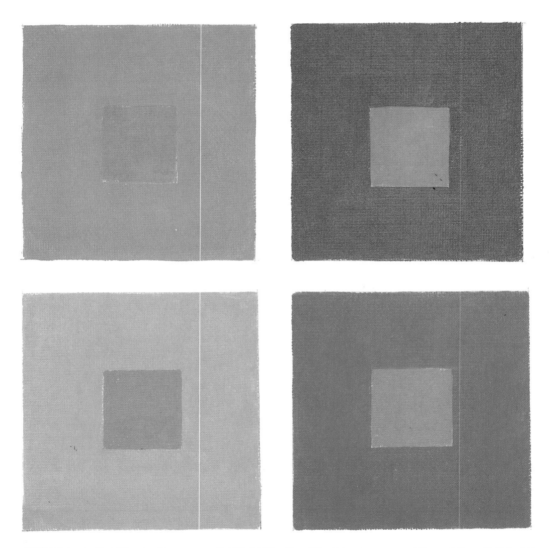

Notice how each of the center squares is affected by the different colors around them. Although they are exactly the same color and value, they appear to vary when subjected to different surroundings. The blue and green squares are the same values, but see how the square in the center of the green stands out against its complement, while the square within the blue seems more absorbed by its surrounding. The value of the center square also seems much darker when surrounded by a neutral and light gray than it does when in the middle of a dark yellow.

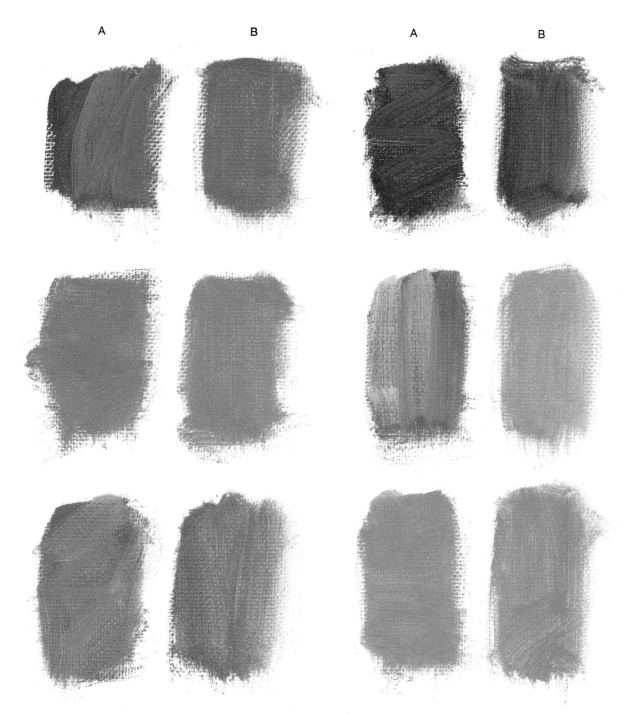

Another method I use to liven up paint application is to mix color and pigment directly on the canvas. This produces effects that can't be achieved any other way. It's similar to placing colors side by side to mix visually, but it gives the effect of a single stroke that's filled with more than one color. By not completely mixing two or more colors into a single color, an otherwise dull and lifeless area can appear lively and exciting.

Try putting one color down on your canvas, then drag another color over the top of it. The results might be just what you're looking for, a mixture of colors that doesn't appear flat and dull. A palette knife can also be used very effectively to run colors together on the canvas.

The swatches in the A columns show the effect of one color laid over another color on the canvas. Both colors are evident, creating a visual mixture that is more pleasing than the single color made by mixing the two together, as shown in the B columns.

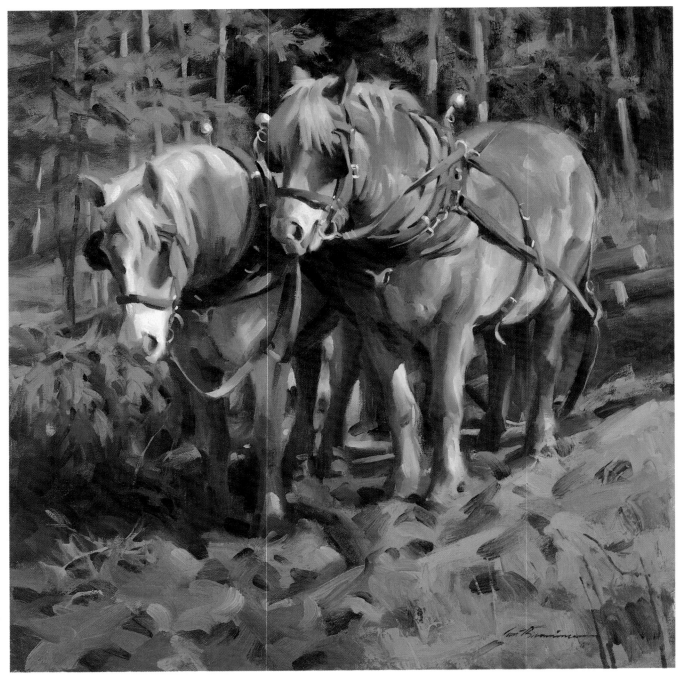

Oregon Skidders, *Oil, 20″×20″*

I did quite a bit of mixing paint and colors directly on the canvas in this painting. It's probably most evident in the muddy foreground, where the eye is allowed to mix some of the colors.

Choosing Your Palette

The colors selected by any painter are a personal choice. If you don't like to do a lot of color mixing, then your palette will probably have a lot of colors on it. If, on the other hand, you're at all like me and love the excitement and challenge of mixing colors, then fewer colors will make up your palette.

Many beginning students like to have a lot of different colors on their palette. And if there isn't enough room there, they keep more tubes within easy reach. Usually the result is a painting with too many colors and not enough harmony. If students learn early on how to mix secondary colors from their primaries, they will feel more dependent on themselves and less dependent on the paint manufacturers. Obviously, there are some colors in nature that require a certain color of paint in order to be convincing. The aqua colors of a Caribbean bay are tough to match without cerulean blue. And some floral colors are best captured by particular tubes of color. In other words, there are exceptions. But for the most part, a simple palette will give you the colors you desire and also keep you out of harmony trouble.

So, how simple is a simple palette? The Swedish painter Anders Zorn (1860-1920) was known to have used a palette of black, white, yellow ochre and vermilion. You can't get much more simple than that. The array of colors that can be mixed from this combination is amazing. And since all of the resulting colors are mixed from the same source, they're also in harmony.

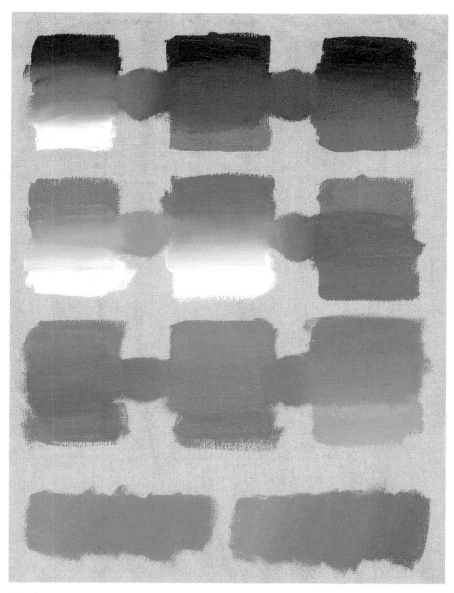

The Swedish painter Anders Zorn frequently used a palette consisting of black, ochre, vermilion and white. Here you can see the range of hues attained by mixtures of these few colors. Try setting up a simple palette with just one variation of each of the primary colors, and mix as many different combinations as you can. You can really learn a lot about color mixing by trying out several different palettes.

Sea Breeze, *Oil, 14″ × 15″*

This is one example of a painting I did using the same colors that Zorn used. I added a touch of cerulean blue for the water and a bit of Thalo Red Rose for the small flowers in the foreground. The rest is composed of harmonious mixtures from this simple palette.

I have seen examples of Zorn's paintings that obviously required colors other than yellow ochre and vermilion, but the point is that beautiful paintings are possible from a very limited palette. I tried this particular choice of colors myself for about two months and was astounded at how much I learned about mixing colors. Another thing a limited palette allows you to do is concentrate on drawing and values and be less concerned about colors and achieving harmony. Even though I enjoyed using the Zorn palette for a while, I knew that I would go back to using more colors as I did

before experimenting. However, I was surprised to find that I continued to use fewer colors, and I still maintain a trimmer palette. I suggest you try the Zorn palette sometime. It's valuable and fun.

My current and basic palette consists of ivory black, cobalt blue, yellow ochre, vermilion, cadmium red light, cadmium orange, cadmium yellow, and titanium white. Depending on the subject matter, I sometimes add one or more of what I call my *occasional* colors. The only time they're on my palette is when the painting at hand calls for them. These additional colors are viridian, Thalo Red Rose, alizarin crimson, burnt sienna, ultramarine blue, cerulean blue, and cadmium yellow light. From this array of colors I can mix just about any color I see. And occasionally, rather than putting ivory black on my palette, I'll make a mixture of burnt sienna and ultramarine blue. It makes a beautiful black that is deep and rich, and its hue can be altered by adding more of one color than the other.

Keep in mind that it's not as important to precisely match the color of something as it is to get that color to work in your painting. And don't think that because you use the same colors for a hundred or more paintings they will automatically all look alike. An infinite number of color schemes can come from the same palette.

First Day at the Beach, *Oil, 18" × 16"*

This painting and the two on the next page show three different color schemes, all from my same basic palette. Using the same colors over and over doesn't mean that all of your paintings are going to, or have to, look the same.

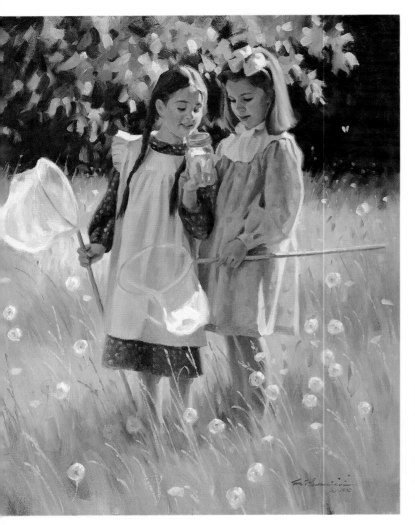

Butterflies and Dandelions, *Oil, 20″ × 16″*

Butterflies, *Oil, 24″ × 20″*

Good paintings usually contain a minimal number of hues, but variations in value and intensity can give the appearance of a wide range of color differences. However, the number of colors on a palette and the decision of which colors to use is up to you. It's a personal choice, and your painting is a personal statement. I've seen a lot of paintings absolutely loaded with color from every part of the spectrum. Some were magnificent, while others didn't work well at all. It depends on how the artist handles those colors as well as all of the elements of painting in one particular piece. Remember, the success of a painting isn't determined by color alone, nor by values or good drawing. All of the elements of painting have to work together to keep the viewer's interest. The last thing you want to hear about one of your paintings is "This is a nice painting, but the colors are off" or "What beautiful color, too bad the drawing isn't better." But if you do hear such comments, take note of them and be honest with yourself when you look at the painting again. If you see that the criticism has some validity to it, then it's up to you to do something about it. When you have an area that needs more attention, learn as much as you can to improve and strengthen that particular aspect of your work. That's what will help make you a better artist.

In this early version of a painting you can probably see where I really missed the mark. The intense yellow and green foliage behind the standing figure is screaming for attention. The first time someone mentioned this to me, I passed it off. But the second time I heard it, I looked at the painting and I was astounded at how my mistake was jumping out at me.

At the Pond, *Oil, 24″ × 24″*

All too happily I painted out the bright yellow of the branches and set them in shadow so that the standing figure is assured her role as center of interest. No matter how radical a change in a painting might be, if it's going to make it better, I'll do it with a smile.

Color Temperature

A lot of students ask, "How can you tell what the temperature of a color is?" Naturally, colors don't have assigned degrees of temperature, so we're really only talking about warm hues and cool hues. That's not to say the subject should be dismissed as something that simple. On the contrary, color temperatures can control the impact of a painting and add convincing realism.

The most basic theory of color temperature in painting that everyone accepts is the idea that *warm colors advance while cool colors recede*. Simply put, the warm advancing colors are yellows, oranges and reds. Cool receding colors are greens, blues and violets. This advancing and receding relationship has to be kept in proper context, however, because a color in your painting that might register as warm and advancing will appear to be cool and receding when placed next to a yet warmer advancing color.

Try covering a small piece of paper or canvas with a mixture of a neutral blue. Now in the center of this field place a spot of neutralized yellow. You can see how the warm color pops out at you while the cool field around it stays in the background. Try it with different color schemes and see which color mixtures best demonstrate this advancing and receding relationship. Then try adjusting the intensities. You'll see how a more intense color will attract the eye away from a more neutral hue.

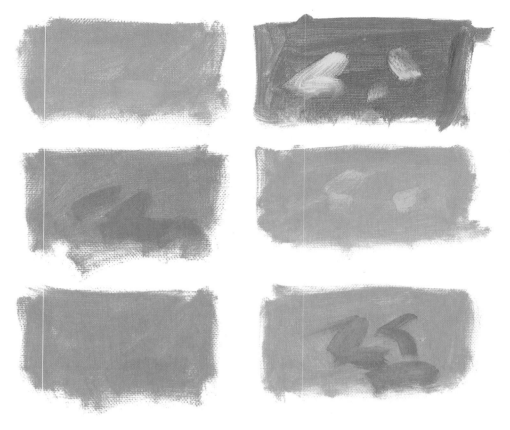

These simple swatches show how warm colors advance against a cool and more neutral background. On the right, the warm colors are intensified and they advance even more.

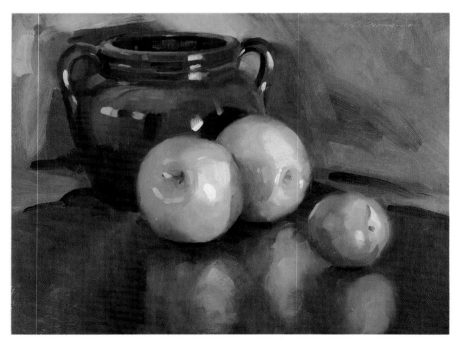

Still Life With Fruit, *Oil, 12" × 16"*

The apples and nectarine, like the spots of color in the swatches, are both warm and intense, and really stand out against the cooler and more neutral colors of the background.

This temperature relationship would also apply if you have an array of reds on your palette. Some will be warm reds and some will be cool. For example, cadmium red medium has yellow in it, so it is a warm red. But Thalo Red Rose and rose madder have blue in them so they are cool reds. The same applies to yellows, blues and greens. Some are warmer than others. I find it valuable to determine the temperature of a color new to my palette before using it. This keeps me from trying to warm a mixture with a cool color and vice versa. So when setting up your palette, you might want to include a warm and cool version of each of the primaries.

I find it helpful to use a different brush in warm paint mixtures than I use in cool paints. It's easier to cool off a warm color than it is to warm up a cool color, so I like to keep my palette and brushes as clean as possible to avoid these unwanted intrusions of cool into warm.

In the swatches at right, I've taken three different color mixes—lavender, yellow and red—and shown what happens to their temperature when other colors of varying temperatures are introduced. Try laying out several swatches of the same cool color. Then mix different warm colors into them and see which colors have the best warming effect. Then lay out swatches of different cool colors and try warming them.

Here I've laid down four swatches of lavender, four of yellow, and four of red. I then ran warm colors up into the lavender to see how a cool color can be warmed up to different degrees. I then cooled off the yellow in the same manner. Red is usually considered a warm color, depending on the mix. Here you can see how it can be both cooled and warmed, and how a very cool and dark color like cobalt blue affects it.

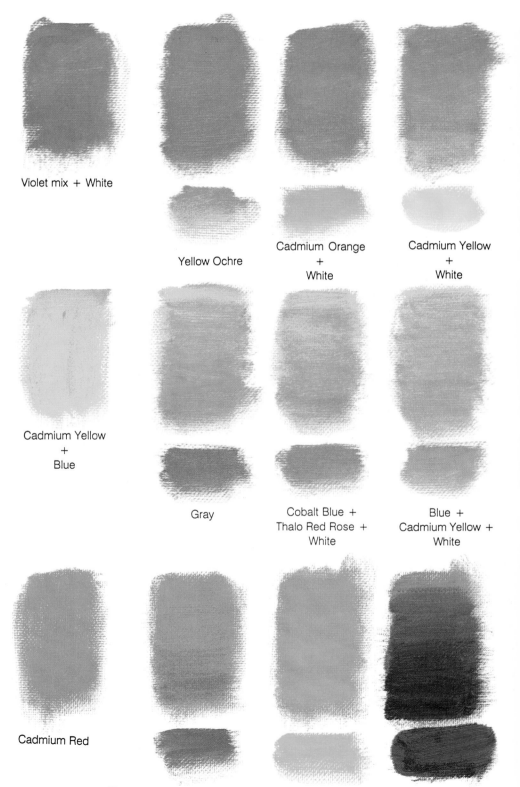

Violet mix + White

Yellow Ochre

Cadmium Orange + White

Cadmium Yellow + White

Cadmium Yellow + Blue

Gray

Cobalt Blue + Thalo Red Rose + White

Blue + Cadmium Yellow + White

Cadmium Red

Thalo Red Rose + Cobalt Blue

Cadmium Yellow

Cobalt Blue

The relationship of advancing and receding colors can prove important in planning your painting. When setting up a still life or posing a model, try to limit warm advancing colors to a small area. They attract attention, and the brightest and warmest area should be reserved for your center of interest. By comparison, background colors work best when kept neutral and cool. A background that vies for attention with bright and warm colors not only distracts from your main focal point, but also loses its place in the painting. Your background should support your center of interest, not compete with it.

Blossoms in Blue, *Oil, 24″×24″*

(Above.) This is a painting about temperatures. I've taken a blue vase and, by warming it up, made it stand out against a blue background. The gold cup has a tendency to catch the viewer's eye. However, I've kept this bright spot in the painting to a small area so as not to give it too much significance.

Christina's Garden, *Oil, 14″×11″*

(Right.) I wanted the butterfly net to be bright, but kept it somewhat cool so it would hold its place behind the girl's warm head. The warm intensity of the yellow flowers pops them right out front.

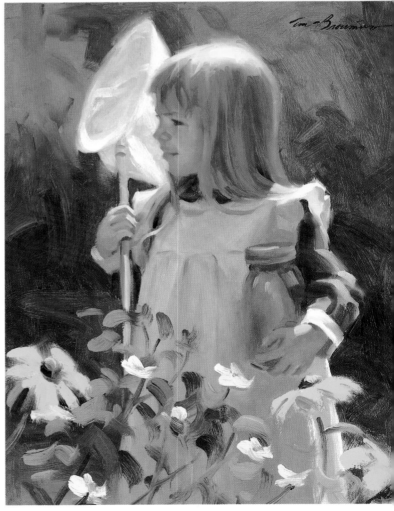

As with values, all colors are affected by the type of light that illuminates them. Color temperatures are affected by the light source as well. An object or scene that is lit by the morning sun will appear cooler than when it is illuminated by the sun at high noon. And in late afternoon everything basks in a very warm light with contrasting cool shadows. In your studio, your lights make a difference, too. If your subject is sitting beneath a skylight, for example, cool colors will prevail when compared to being lit by an incandescent spotlight.

After the Withering Vines, *Oil, 20" × 24"*

(Above.) The light of a late afternoon sun tends to warm everything with a nice yellow glow. By contrast, the shadows are usually cool, reflecting the blue of the sky above.

Early Spring, *Oil, 30" × 40"*

(Below.) A mid-morning sunlight tends to be much cooler. Whites are not as warm as they would be later in the day. Under these conditions shadows seem to take on more colors of what's around them since the sun is becoming more intense, allowing more light into the shadows.

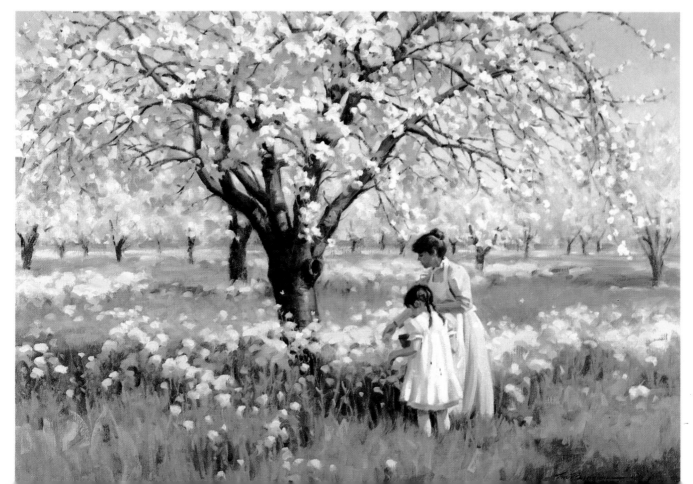

Don't be misled into thinking that if a light source is warm that all colors in the painting should be warm. For a painting to work, there has to be a proper balance of warm and cool colors. It's this balance of temperatures as well as the contrast of cool and warm that helps give the proper sense of light in a picture. For warm colors to register properly, there must be some cooler hues somewhere in the painting.

Waiting for a Breeze, *Oil, 16″ × 14″*

Although a mid-afternoon sun is starting to warm things up, I like to add enough cool areas of color to balance the picture. Although the sun is adding warmth to the scene, the sky is contributing plenty of blue to the shadows.

One of the first mistakes that students make regarding color temperatures is trying to use logic rather than observation. There's always a student who will reason that on a warm sunny day the warm light of the sun will cause objects to be warm on top, and insists that areas underneath shaded from the sun must be cool. Observation will reveal the exact opposite. And after observation comes a more truthful logic. The top surfaces of the objects in the scene would more likely be reflecting the blue of the sky, causing them to appear cool. Those areas turned away from the sun and on the bottom side of the objects would be receiving reflected light from the ground, creating a warm effect.

Obviously, every situation will present a different set of circumstances, so this can't be considered a hard-and-fast rule. Again, observation is the most effective way to determine temperatures. After a while you'll observe conditions often enough that it becomes second nature to see if your own little rules exist in the scene you're painting. Then, with increasing confidence, you'll begin adding things instinctively and spontaneously. This exciting part of creating helps turn simple paintings into art.

WRONG

A lot of students reason that the warm rays of the sun are going to warm everything on the top surface, and the shadowed sides of objects will be cool from the lack of warm light.

RIGHT

The warm light of the sun will actually bounce back up into the object as reflected light. This generally has a warming effect as you can see on the belly of this horse. And the top surface of the object will reflect the colors of the sky above.

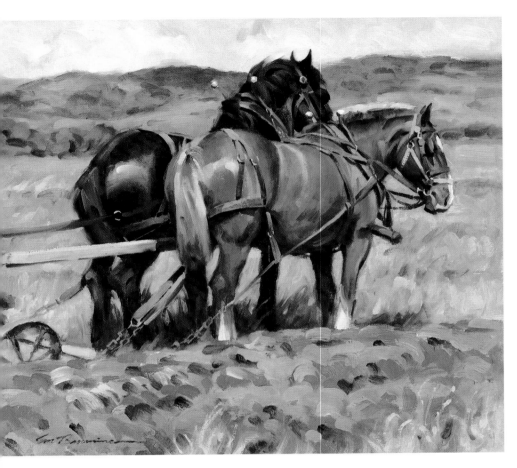

Spring Team, *Oil, 14″ × 18″*

While looking at this painting, remember some of the things I've been discussing throughout this chapter. Cooler colors of the landscape recede while the warmer colors advance. The hard surfaces of the overturned sod reflect the coolness of the sky while the grass, even though on the same plane, tends to absorb more of the warm light.

Sonnets in the Garden, *Oil, 14″ × 18″*

The figure in the white dress is receiving a warm reflection from the open book. Meanwhile, the portions of her dress that are in shadow are cool.

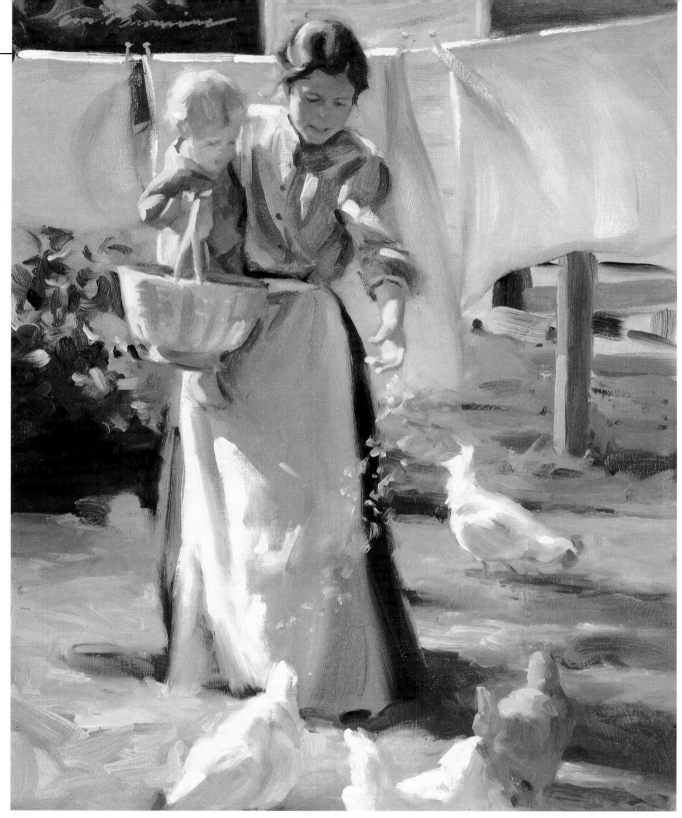

Saturday Morning Chores, *Oil, 14″ × 11″*

While doing this painting I remember having fun playing around with the warms and cools.
The baby, the basket, the chickens, even the laundry depict this warm and cool contrast.

Observing and Comparing Colors

When I observe color in order to translate what I see into paint, I go through a series of mental questions that let me know at which piles of paint to aim my brush. It takes only a few seconds, and I'm not really conscious of asking myself anything at all, but when I dissect the process, that's exactly what happens. I'll take an object such as a pumpkin and go through the steps.

Q. *What is the local color?*
A. Orange.
Q. *What is the hue more specifically?*
A. Add yellow.
Q. *What is the value?*
A. Using the background, and the shadowed side of the pumpkin for comparison, I estimate the value.
Q. *What is the intensity?*
A. Comparing the pumpkin to my paint mixture, I see that my paint is a little too intense, so I add a little yellow ochre to the mix. I compare again, then apply paint.

This process is done for every mixture of paint, whether mixed on the palette or on the canvas. I continue with the same questions to mix the color for the background and the shadowed side of the pumpkin. As the painting progresses, I continually ask questions about values, temperatures, and so forth. The answers to all my questions are right there in front of me. I simply have to look, compare and make a decision.

I suggested in the first chapter to try squinting your eyes to help read values. This also works for determining the other components of color. Another thing that helps in deciding what hues to add to a local color is to look right beyond your subject in question. Don't stare at the object itself, but look at the color of the background that surrounds the area you want to identify. Focus on the background and its color, and out of the corner of your eye take in the object without looking directly at it. It will appear fuzzy, but its relationship with the background will be evident. This can help you pick a color that is more expressive yet in tone with the rest of the scene.

Step 1
In beginning this simple setup, the value contrast of the pumpkin and background is the most obvious, so I picked an approximate dark for the background. I asked myself what the local color of the pumpkin was, and quickly refined it on the palette. After laying in the lighted side of the pumpkin, I asked the same question for finding the appropriate colors of the shadowed side.

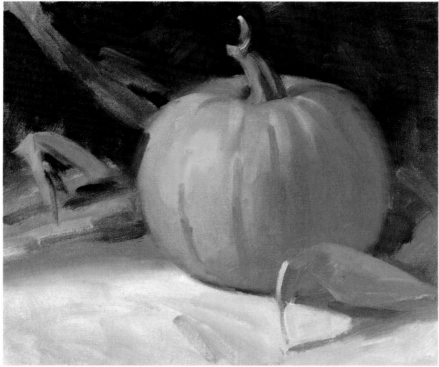

Step 2

By constantly comparing the subject with my canvas, I did more refining of hues and values. I then found the approximate color and value of the corn stalks. Comparing them with the pumpkin, I could easily see the difference in intensities.

Step 3

I spent a little more time adjusting values and hues all over the painting until I felt I'd gone far enough with it.

Harmony in Color

When setting up the scene you want to paint, keep in mind that most successful paintings have a dominant hue, or one color used more in proportion to other colors. It might be in the form of a background, or it could be the center of interest. Whatever the scheme of your painting, colors should not be used in equal proportions throughout the picture. I'll discuss this further in chapter four, on composition, but I want to mention it at this point. If you are concerned about achieving color harmony in your paintings, start by considering the dominant hue's placement on the color wheel.

Let's say that you want your picture to have a dominant hue of green. If those hues adjacent to green on the color wheel — blue-green and yellow-green — were, along with green, the only colors used in your painting, it would be in perfect color harmony. Although that limited use of color is seldom the case, you can see how all three hues are composed of green, the dominating hue, and thus create harmony. To carry it further, if any other colors used in this particular painting contained a little bit of green, they would be more in harmony than if they

In the Cellar, *Oil, 16″×20″*

The purples and crimsons of the red onions do not exist solely on these objects. A reddish tone runs all through the background, basket and foreground, creating the dominant hue, although the onions are in fact much more intense. The pot and white onions, on the other hand, are a little more foreign to the overall color scheme. This coupled with their light values makes them the center of interest.

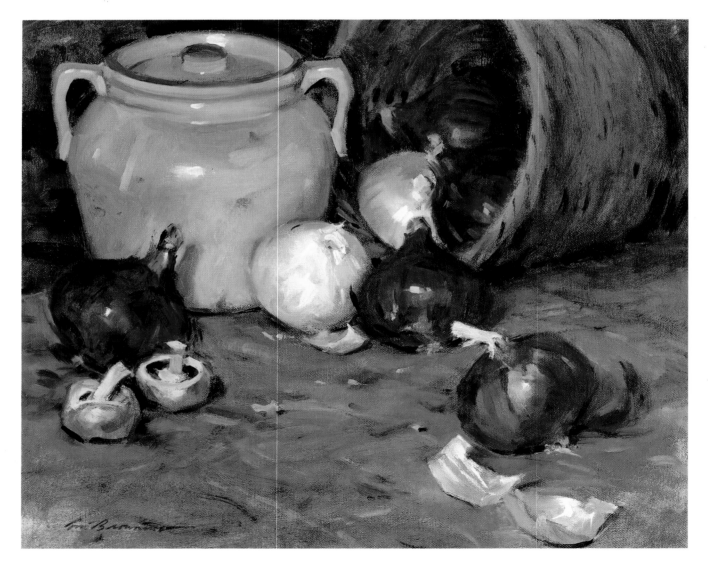

had no green in them at all. Even the dominant hue's complement, red, should have some green in it to temper its intensity and keep it in harmony. In fact, I will most often make a point of having the dominant hue's complement somewhere in the picture, because this too has a harmonious effect.

I have to admit that I don't pay as much attention to harmonizing schemes as I could. I learned a long time ago that when everything in a scene is bathed in the same type of light, the scene itself is automatically harmonized. So if I stay fairly close to the colors that I see when I'm mixing colors, the painting will be in fairly close harmony. But I'll also be the first to admit that going beyond what we actually see, and intentionally harmonizing colors for art's sake can not only enhance, but be the subtle key behind the success of a painting. It's a simple concept and I highly recommend learning to look for harmony in your subject and then giving it that extra nudge on your canvas.

Western Meadow, *Oil, 20" × 24"*

Green is the dominant hue in this painting. Yellows and blues used throughout these greens keep the painting harmonious, since they are all from the same portion of the color wheel. Green's complement, red, is also used throughout the painting for balance, although it in no way distracts from the green or begs for attention.

Beneath the Arbor, *Oil, 14" × 18"*

Here's an example of a very warm background supporting cooler objects in the foreground. The reason it doesn't tend to come forward is due to the cool colors I added to the leaves, as well as the light values of the white garments.

A Seven-Step Summary to Help You Observe Colors

1. Values, hues and intensities are determined by the type of light falling on the subject. As the light changes, so will these three dimensions of color.

2. Depending on what colors are mixed, hues, values and intensities will more than likely change simultaneously.

3. Warm colors advance and cool colors recede. Before using a color to mix with another, know whether it tends to be warm or cool.

4. Observe your subject before trying to apply logic. The answers to questions of temperatures, hues, values and intensities are all right there. Observation and comparison is the surest way to arrive at the proper paint mixture.

5. When determining what colors to mix for your subject, ask "What is the local color? What is its hue? What is its value? What is its intensity?"

6. Compare your subject with those areas around it. Don't stare at your subject. Keep your eyes moving and constantly compare areas.

7. In all aspects of painting, whether it's values, composition or color, one thing must dominate. To achieve harmony in your picture, determine the dominant hue's placement on the color wheel. Using colors adjacent to this throughout the painting is the surest way to bring about harmony. And it may be more truthful to the scene than you think.

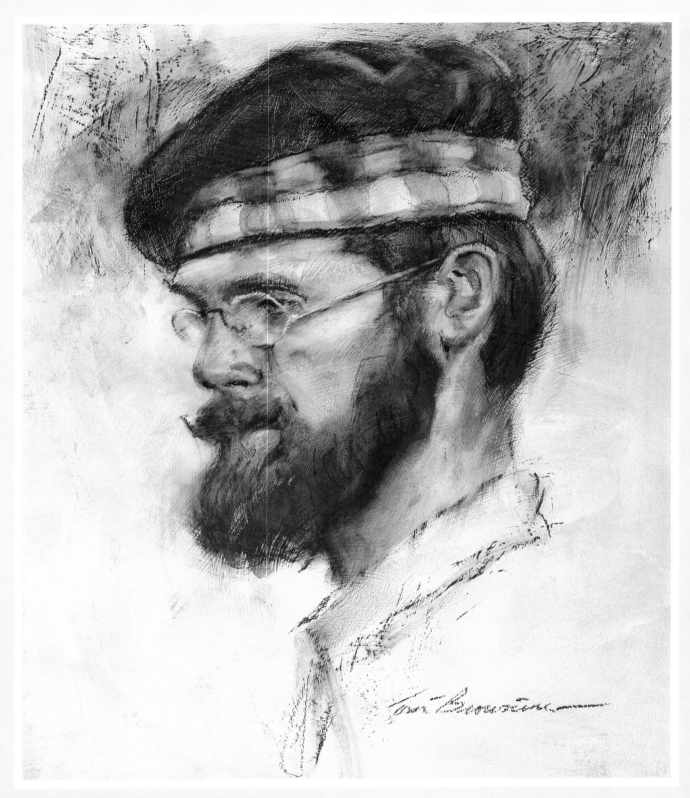

The Scotsman, *Conté crayon on gessoed illustration board, 12″ × 10″*

DRAWING SIMPLIFIED

For as long as I can remember, I've been drawing. I began as a child by copying simple drawings and cartoons, then progressed to trying to duplicate with a pencil photographs of horses and wildlife. I remember getting my first official drawing kit when I was ten. In some form or another I've been drawing ever since. Drawing, as you know, is the foundation of any representational painting, so its importance is obvious. But drawing is a subject that has many aspects, and I can't begin to cover them all in one chapter. Nor is this chapter designed to provide much instruction in how to draw. Drawing is a process that is learned through practice. Its beginnings are basically hand-eye coordination, where improvement comes with continued effort.

My approach to painting is based on sound drawing. I'm drawing from the first stroke to the last. In this chapter I'll deal with the convenience of drawing with a brush, and demonstrate ways to build the confidence necessary to paint freely and honestly.

Loosen-Up Exercises

Although I've drawn in some form or another nearly all my life, I still need to continue with quick sketches and drawing from life. I attend a drawing group as often as my schedule allows, and occasionally when it doesn't. I can't stress enough the importance of continuing to draw for the sake of drawing, even if you work from photographs. It's like physical exercise. Just as you need to keep exercising to stay fit and healthy, you need to keep drawing to keep from getting rusty. You have to keep the eye working with the hand as much as possible. I've noticed that when I don't attend these drawing sessions or have a model come to the studio, it begins to show in my painting.

For these drawing sessions, I like to use vine charcoal or Conté crayon. Since it's for the practice, I try to keep the cost down by using the most inexpensive newsprint I can find.

Once I start, I want the motion of my entire arm and wrist to help me draw, so I hold the charcoal loosely in my hand between my thumb and forefinger. I never hold it like a pencil. This would restrict the motion of my arm and lead to a stiff-looking drawing that would more than likely be out of proportion.

A nude model is definitely best for practice in drawing the figure. Even if the subjects you paint are fully clothed figures, you still need to understand the form that lies beneath the clothing. This helps you better understand the folds and wrinkles that occur in clothing as the person inside it moves about. If you're unable to work from a nude model, try to find a drawing class at a nearby university or art organization. They often have group drawing sessions like the one I attend. If all else fails, drawing a fully clothed model is not wasted time by any means. If you're able to work from a model in your own studio, all the better. This way you can control the type and length of the poses.

In a real pinch, a wooden artist's mannequin will work. In fact, it's really useful to have around. I use one every once in a while in altering a drawing or checking shadows.

When I can't get a model, or I need just a quick pose for a figure I'm altering in a painting, a wooden mannequin does the trick. They're easily found in most art supply stores.

I can't stress enough the importance of continuing to draw for the sake of drawing, even if you work from photographs.

Observe and Simplify

The best way to start is with some quick ten-second poses. I consider these to be one of the best drawing exercises, and here's why. When you know you have only ten seconds to draw an entire figure, what do you do besides hurry? You look for the lines that best describe.

Ten or fifteen minutes of ten-second poses are like warm-up exercises before a workout. But more important, they help you develop the skill of quick observation. You learn to find the important elements and zero in on them. You're also in effect reinforcing the process of editing out nonessential detail. When you do this often enough, you'll see it begin to carry over into your painting.

Look for the lines that best describe.

After a series of ten-second poses, give the model a rest, then resume with twenty or thirty minutes of thirty-second poses. After the ten-second poses, you'll be amazed at how long these seem to last. Again, go for the important lines first, those that best describe the pose. You'll have a little extra time to complete more of the figure, but don't spend time trying to define certain areas too precisely. Just concern yourself with getting down the gesture of the model's pose. This is the very reason these are known as *gesture drawings.*

(Above.) With just a few seconds to draw a figure, you're forced to find the lines and forms that best describe a particular pose. Although these ten-second sketches don't look like much, practicing quick observation can be beneficial to many aspects of your work.

(Right.) Thirty seconds give you just a little more time to cover the entire figure. Again, repetition of this exercise will help improve your skill as a draughtsman.

Another quick and easy way to capture the gesture of a figure is not with line, but with mass. By using the side of the charcoal instead of the point, a wide area can be massed in with one stroke. By turning the charcoal in your fingers, a thinner line can also be achieved. In a sense, this helps you look for important areas of shadows that help define the form.

By this time you should be fairly warmed up, so have the model hold poses for one to two minutes. At first, they seem like five-minute poses, so you'll probably find yourself starting to draw more slowly and trying to be more accurate. Don't. Use a little less pressure on your pencil or charcoal, but try to maintain the spontaneity developed in the quicker poses. With the additional time, go back over the drawing finding more accurate and truer lines. This will help keep your drawings from looking stiff.

At this point you might want to have the model hold poses for extended periods of time. This is helpful for doing finished drawings and developing a style or technique in charcoal or pencil. After a while, you'll probably find that the quick gesture drawings done in thirty seconds appear more expressive and just as accurate as those you spend much longer doing. My best advice is to stay loose and relaxed when drawing longer poses. If you find yourself drawing stiff-looking figures, then go back to the quicker poses to loosen up.

The mass and form of a figure can be quickly blocked in with the side of your charcoal. Line can then be used to add more definition.

When doing a two-minute pose, begin by quickly capturing the gesture of the pose. Then go back over the drawing finding truer lines for more accuracy.

With a fifteen- or twenty-minute pose you can take your sketches a little further. Just remember to nail down the overall gesture before going on to any additional rendering.

Drawing With a Brush

For me, the benefit of the drawing sessions is the development of speed and accuracy. On nights that the models hold one- or two-hour poses I take along my paint box, and rather than draw with pencil and paper, I sketch using brushes and paint. This helps develop speed and accuracy directly in the area that I need it the most — painting.

I know that a lot of artists begin their paintings by drawing their subject in with charcoal. I prefer getting directly into the painting with a brush. Although accuracy is important, it's not necessary to get the painting underway. I feel I have the course of the entire painting to redraw and reshape lines and masses, looking for the most accurate strokes. I've found that when students think they have the most accurate drawing possible on their canvas, they often try to stay within the lines as they paint, not wanting to disturb their drawing. This leads to a paint-by-number appearance that's stiff and hard-edged. If you tell yourself the drawing can be changed throughout the painting, you'll maintain a more expressive and fresh look to your work.

If you don't currently draw your subject onto your canvas with a brush, I recommend you give it a try. Here's an exercise to help you develop this method.

First, the way you hold the brush is important. I like to hold the brush about halfway up the handle. Oil

For poses that are an hour or longer, I prefer to sketch with a brush. It's more applicable to what I like to do, so the benefits are even greater.

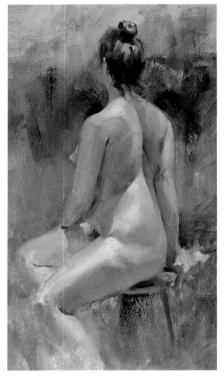

Just as with the charcoal sketches, these oil studies can be taken as far as you like.

brush handles are made long to keep us a comfortable distance from the canvas. Again, I let my entire arm get into the act to establish the drawing as freely as possible.

With your brush, select a moderate amount of a neutral color such as a mixture of yellow ochre and violet. Add a fair amount of thinner or turpentine until the mixture becomes soupy. In a limited amount of time, say thirty seconds to a minute, use your brush to draw your subject directly on the canvas. You can use either a model or still-life objects, but the important

thing is to limit the amount of time you give yourself. After you've established the composition and forms, without becoming attached to the drawing, rub it out with a brush full of thinner. Wipe the canvas off, and begin again. The main idea of this exercise is to build confidence in drawing with a brush. Repeat this as many times as it takes to get comfortable with the process. Once you get the hang of starting a painting like this, you won't want to start any other way.

Mistakes Are Easy to Change

Another benefit of the exercise I just described is the convenience that comes with the confidence. When you labor over a drawing before applying paint, you will be very reluctant to make many changes after the painting process has begun. But if you do the drawing in just a few minutes, changes aren't going to seem very bothersome at all. Plus, making changes near the completion of the painting won't seem as intimidating as you might expect. It's all part of the drawing process, and if you make drawing a part of the entire painting process, then changes will become exciting and not intimidating.

The exercise that brings about the fastest improvement in my students is one where I have them complete a small painting within thirty minutes. Then, as in the previous exercise, I have them rub the painting out and begin again. I have them repeat this exercise until I see that they stop making the same mistakes over and over. This may sound unsympathetic, but although it does destroy the painting, it also destroys the fear of making necessary changes in the middle of a painting. If you don't get accustomed to the idea that every stroke is not sacred, you'll miss the opportunity to improve upon what you have. So the idea of many beginnings is what is important. I want the student to know that it's just as easy to start over as it is to wipe out a painting. This is what builds confidence and ability. There have even been times that I've suggested a painting be saved, but the student preferred to wipe it out, knowing he could do better. To me, this showed growing confidence and maturity, and more important, the will and desire to improve.

More Mass, Less Line

Nature doesn't really have lines, it has form. Man has always tried to depict these forms with lines, so in a sense, they're more like symbols. Sometimes lines are the best way to describe a form, because they establish an image quickly and precisely. But line is not the only way and not necessarily the most realistic way to depict form, so consider establishing the form with mass instead.

When laying in a painting with a brush, it's often helpful to look for the masses and put them in without the use of so much line. This quickly establishes shadows and patterns as well as builds a foundation of loosely formed edges that lend themselves to more free and expressive brushwork. Besides, initial lines are usually painted over and lost anyway. I often use this approach because it's quick and it retains a look of unity as one form merges with another.

Set up an object and, with a wide brush, block in the shadowed side as well as any cast shadows. Don't be concerned about drawing an outline of the object first, although you'll be tempted; just concentrate on the shadows and form. More defining lines can be added later. Even without lines this is still a way of drawing that can be used to establish form, values and composition.

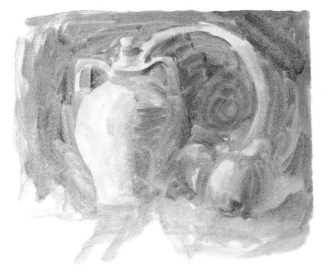

Try laying in a painting without the use of lines. Use a wide brush and just concentrate on the forms, masses and shadows.

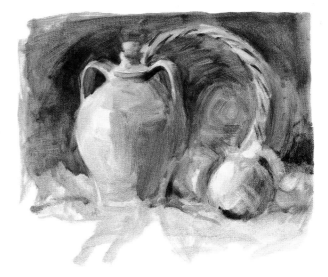

More definition can be added after the basic forms are established. Only fifteen minutes have been spent to get to this point and the finish work can now be taken as far as I like. Sometimes I feel that from this point the painting seems to paint itself.

Drawing Continues

After the subject has been drawn in and the paint starts going onto the canvas, I continue to draw throughout the course of the painting. If an object is too wide, I can bring in the background and, like a sculptor, carve out a change in the width or shape of the object.

I consider every stroke to be a form of drawing. Whether I'm adding an entire object or simply redefining an edge, I'm still drawing. Quite often there are areas that I don't bother drawing in at the beginning, because I know this initial effort would be covered up. Instead, I first paint the form with its proper planes and values, then put down strokes that will remain untouched. Examples are such things as patterns on cloth or porcelain, or maybe a lacy design in a curtain. To

draw all of these little details ahead of time would be time wasted. This approach lends itself very well to a suggestive style of painting. And I feel if I were to do a detailed drawing and then use paint to color it in, the whole process would seem pointless and laborious, and I'd probably give it up.

That's why my initial drawing on the canvas is sketchy and without much detail. I use it more as a rough guide for placing my colors and values. Obviously, the more accurate the overall drawing is, the fewer changes I'll have to make later. And although it is easier to change drawing in the beginning stages, sometimes I just don't spot drawing problems until I'm well into the painting. If I stand back and see my drawing is off here or there, I wipe it off and repaint it. For me, this fusion of drawing and painting is what truly keeps my interest in my work alive.

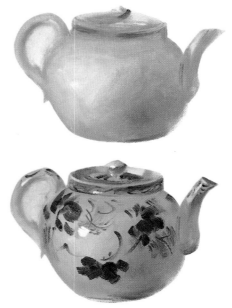

Instead of drawing the decorative work on this teapot before actually painting it, I establish the pot's form, color and values as if it had no decorative designs. This way I'm not painting in and around these little details. I then carefully observe the designs and paint them directly on top of the wet underpainting. I used straight cobalt blue for the designs on the light side of the teapot, and ultramarine blue for those on the shadowed side.

Here I've quickly established the basic form of a small pitcher. I stand back, take a good look at it, and decide I'd like to adjust the overall shape a bit and enlarge the handle so it more closely matches my subject.

I've left visible the drawing of the handle to demonstrate how I make changes in my drawing with brush and paint. As you can see, I rough in the revision before painting out anything. I expect these changes and actually enjoy them. You can also compare this with the first example and see where other changes and adjustments have been made.

Here there is no evidence that the handle had ever been redrawn and the sides of the pitcher adjusted. These changes take a matter of minutes, and the painting can still look direct and confident.

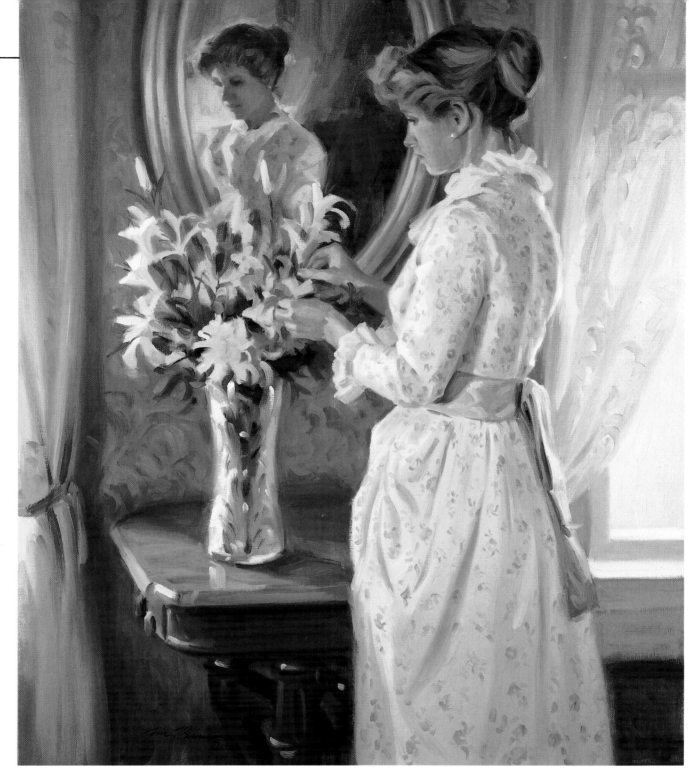

Bouquet for the Parlor, *Oil on canvas, 30″ × 24″*

The suggestion of a lace curtain was painted directly with no preliminary drawing. Even though it was done near the completion of the painting, it was still a form of drawing. The same could be said for the floral pattern on the figure's dress. I first painted in the white dress with all of its folds and shadows. Then with single brushstrokes, I applied the small flowers. Drawing them in beforehand would have been time wasted.

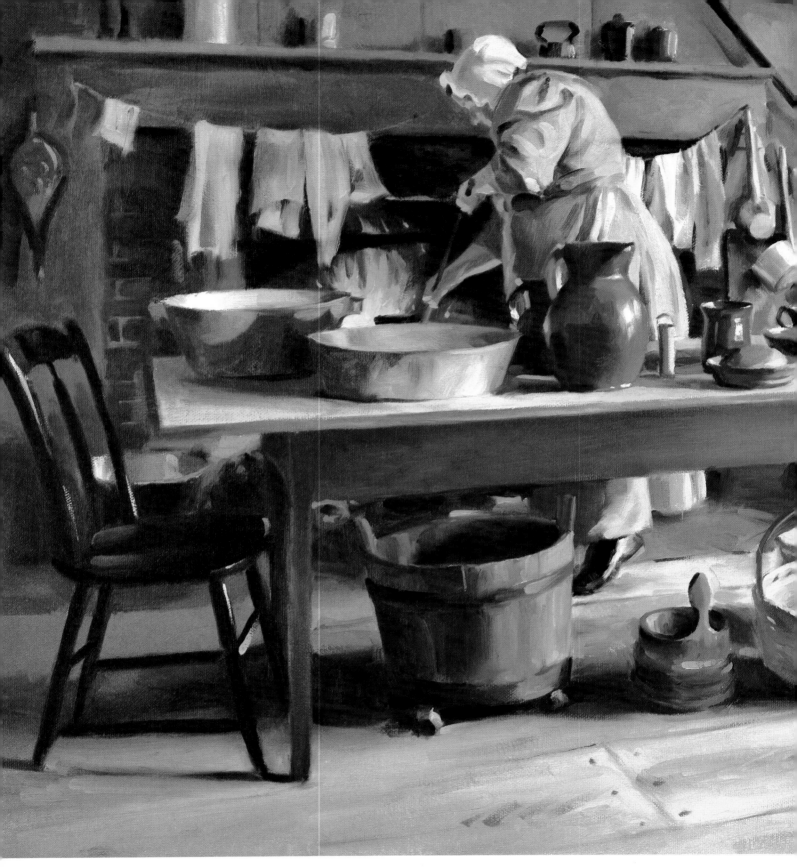

Early Interior, *Oil on canvas, 16" × 20"*

I did this painting from some photos I had taken, and the scene was actually filled with a lot more clutter than you see here. Although I did a lot of editing throughout the course of the painting, there still might be a little too much. I did very little preliminary drawing and enjoyed shifting and rearranging all of the objects on the canvas as I painted.

A Six-Step Summary to Gaining Confidence in Your Drawing

1. Continue to draw for the sake of drawing. It's important to exercise our drawing skills as much as possible. Confidence in drawing skills is one of the most important traits of an artist.

2. Draw from life as often as you can. One of the best drawing exercises is to draw a series of ten-second poses from a live model. This keeps you loose and looking for *lines that best describe*.

3. If you don't already draw with a brush, learn to do it. If you tell yourself that your drawing can easily be changed throughout a painting, you'll keep a more expressive and fresh look to your work. If you first draw everything in with pencil or charcoal, you could be missing out on a lot of excitement and wind up with nothing more than a colored drawing.

4. A good exercise for drawing with a brush is to make a lot of quick starts. Giving yourself limited time, repeat the drawing until you're comfortable with the process. This will also help build confidence in your painting.

5. Never be afraid to change your drawing in the middle of a painting. If you make drawing a part of the entire painting process, then changes will become exciting and not intimidating.

6. Continue drawing throughout the course of the painting. Like a sculptor, you can add or take away at your discretion. Every stroke is a form of drawing, so confidence in your drawing puts confidence into your painting.

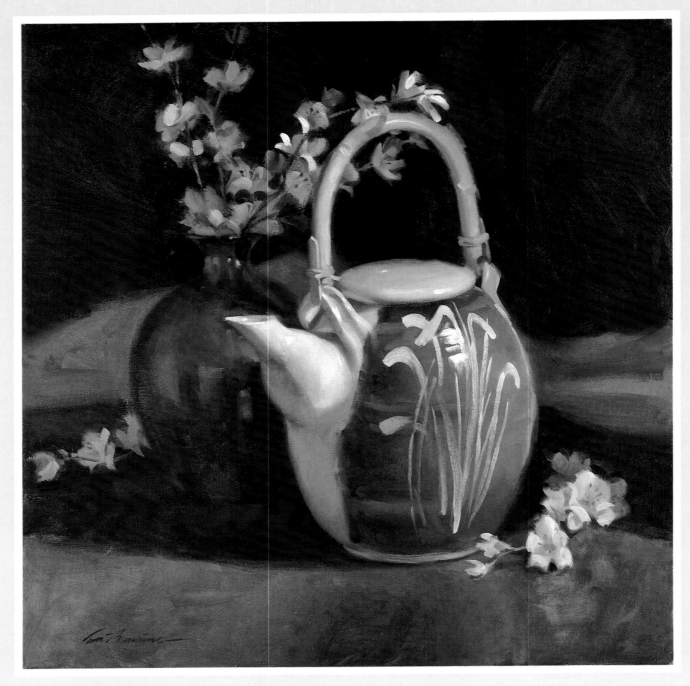

Oriental Blue, *Oil on canvas, 20″ × 20″*

BASIC CONCEPTS OF COMPOSITION

Before I ever lay a brush to my canvas, I need some preconceived notion of where I want the subjects of my painting to be placed. With either a square or rectangular blank canvas, the possibilities are numerous. As with color selection and technique, composition is a personal choice for an artist. I usually prefer simplicity to help state my ideas. This creates a result most pleasing to me. But there's a lot to be considered in order to arrive at a simple composition. Nothing complicated, but understanding some basic concepts helps me make some of those personal choices and decisions.

I know that when I paint a picture I want certain things to happen that will help capture a viewer's attention and hold it for a while. The viewer might not be aware of it, but composition can be a key factor in creating interest in a painting.

The Center of Interest

There are many aspects and elements to composition, and I suppose I could start with any number of them, but what seems to relate to so many of these elements is the *center of interest*. So an early understanding of this is important.

Can you imagine watching a movie that doesn't have a character with a leading role? Just a lot of actors with the same number of lines, none more important than the other. Then imagine the script jumping around from one theme to another. The best word to describe this type of production would be *confusion*. Or imagine your favorite musical performer singing in a choir among fifty other singers. If you went to hear that particular singer, you might be pretty disappointed, for without a solo part, it would be difficult to distinguish your favorite singer from the others.

Paintings can have similar problems. It bothers me to look at a painting that has no obvious center of interest. Without it, I'll normally turn and walk away. So when I approach my own blank canvas, I keep in mind there should be only one major center of interest, and accordingly determine what it will be.

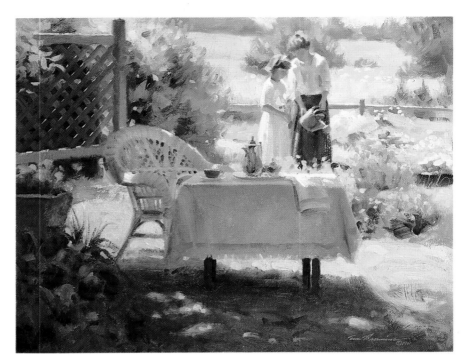

(Above.) This composition isn't exactly confusing, but it has a few areas that compete. The figures in the background are the intended center of interest, but the chair and table attract more attention than they should.

Book and Tea, *Oil on canvas, 18″ × 24″*

Using the same elements in this picture, I developed a stronger center of interest. Here the figure and table together become the focal point, and there's no doubt what the eye sees first in this painting.

Determining the center of interest is not too difficult when the subject matter of the painting is made up of a single figure or object. However, maintaining that figure as the focal point can sometimes be sabotaged by careless use of color or values. When a contrasting color, intensity, or value is placed in some part of the painting away from the intended focal point, a *contest of interest* occurs.

This conflict, whether intentional or not, can interfere with the viewer's ability to focus on the center of interest. While your painting is in progress, see if there is any area of the picture that is taking your eye's attention away from your intended focal area. If there is, figure out why, then try to resolve the problem. It could be in the color intensity or value.

If you think you've solved the problem, but aren't quite sure, have someone else look at your painting and ask them what the first thing is that they see. They don't have to be trained artists; an honest answer is all you're looking for. My wife has become an excellent critic, and I've learned to look to her honest comments to help get me out of unresolved problems.

(Left.) Although this is rather extreme, it illustrates how a contest of interest occurs. The bouquet of flowers is made up of such bright and intense colors that they grab attention before the intended center of interest, the girl reading.

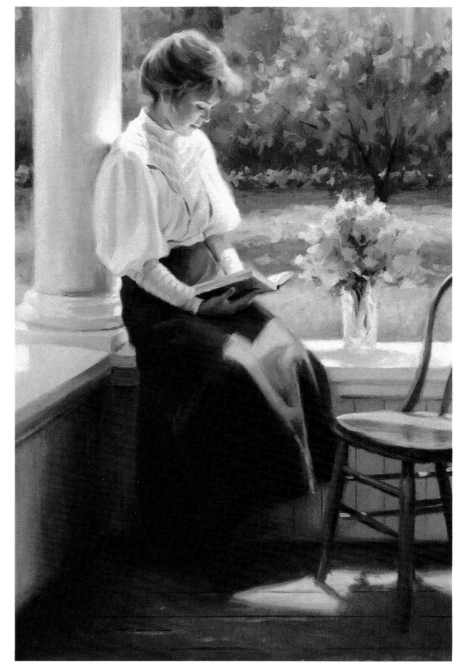

(Right.) When the colors of the flowers are toned down to a color and intensity that's less distracting, the girl reading becomes the first thing to attract the viewer's attention.

A contrast in values is a sure way to draw attention to an area of a composition. Figures A and B display maximum contrast. The black-and-white spots in figures C and D are no easier to see than the contrasting triangles below them.

A

B

C

D

Before going any further, I want to touch on a few things that help strengthen any center of interest. It's important to know how to control the viewer's eye, and although I briefly discussed this in previous chapters, I feel it would be helpful to demonstrate how I find ways to maintain my focal point.

A contrast in values is the most simple and straightforward way to draw attention to any area on a canvas. A very dark area adjacent to a light area will catch the viewer's eye before anything else, and if the area is large enough, it can be seen from clear across the room. If you have an all-white canvas with one spot of black, you'll see it in an instant, no matter how small the spot.

A contrast in colors is also an effective way to control a composition. Yellow on black (A) creates a strong contrast. However, yellow seen against its complement, cobalt violet (B), provides an even stronger contrast. Likewise, the orange in C is not as noticeable as in D, where it's seen against its complement of blue.

A

B

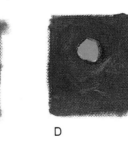

C

D

But contrast in colors can also be an effective means to attract attention. An intense yellow against a black background creates more of a contrast for the eye than black against white. And yellow against a field of its complement of purple results in a contrast even more attracting.

Although I'll be discussing treatment of edges later in the book, they too are an effective way to control the importance of any particular area in a picture. See how a shape with hard edges stands out among shapes with soft edges (at left, bottom). Your eye automatically goes to the hard edges and passes over the softer ones.

The hard-edged shape stands out among the other shapes that all have soft edges. This is yet another form of contrast.

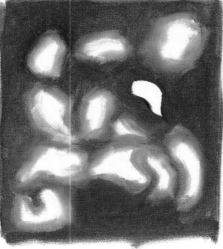

When an artist uses a combination of contrasting values, colors and hard edges, as in *Sister of the Angels*, at right, he can achieve the maximum amount of control over the center of interest, provided the rest of the painting is composed of soft edges, similar colors, and closely related values.

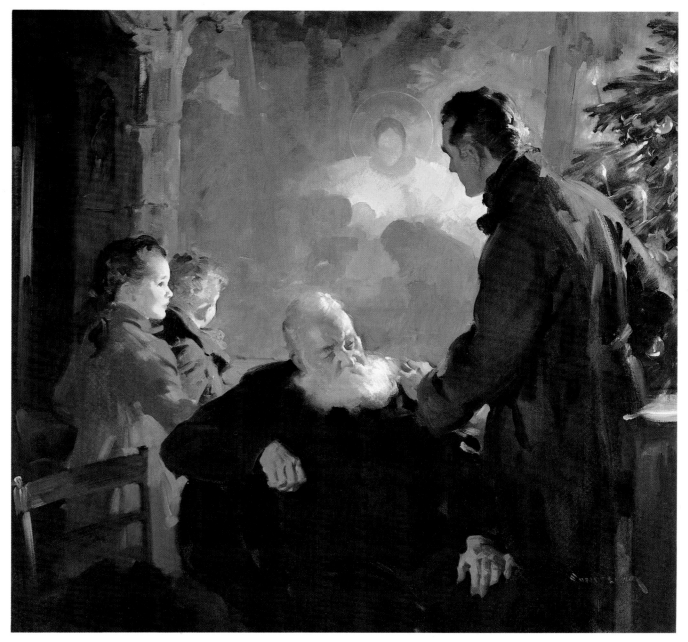

Sister of the Angels, *Haddon Sundblom, Oil on canvas, 29" × 31"*

Again, my hat is off to the great illustrators. I've learned a lot from having this painting in my collection. Its impact is strong and immediate. The dark figure on the right grabs the eye first with its dark values and cool temperatures against the bright and warm background. This contrast of values and colors is further enhanced by the hard edges along the man's face. These factors together make for a striking center of interest that cannot be missed.

Sweet Fragrance, *Oil on panel, 14" × 11"*

The flowers in this picture help support the center of interest, the figure. I was careful to keep them soft and not too intense, so they would maintain their intended roles.

Supporting Roles

Even with the ability to create a strong center of interest, one still needs to know what to do about other objects or figures in the picture. These areas of the picture should be treated in a way that helps *support* the center of interest. Much like the supporting cast

There should be only one dominating area of interest in a painting.

in a play, their purpose is to add interest and variety, and to support the main character. In other words, these supporting roles should hold their places quietly in the picture and not compete with or dominate the intended center of interest. Remember, there should be only one dominating area of interest in a painting.

So, what happens when there are two figures in a painting that need to interact, and neither seems more important than the other? This is when the artist needs to make a decision on what is most important in the painting. Whatever the point of the painting, there still has to be a center of interest and areas of secondary interest to support it. Even though two people engaged in conversation might be equally important, in a painting one or the other has to dominate, or they both have to work together as a single area that dominates in interest.

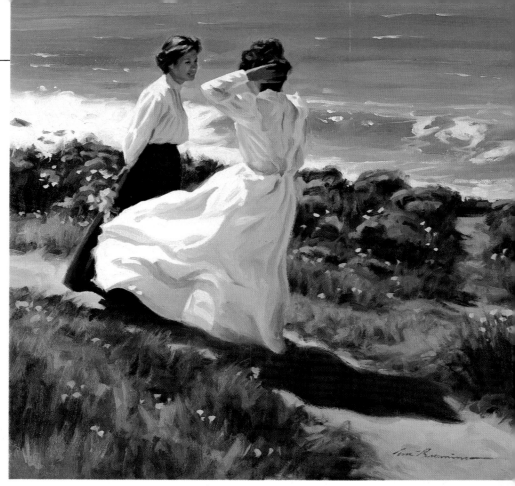

(Right.) The figure with the flowing white dress is the center of interest in this composition. Even though the face of the other figure is shown, she is clearly outdone by the light values of the blowing dress.

(Below.) At first glance, these two figures are seen at the same time. Rather than one dominating over the other, they work together as a unit to form the center of interest.

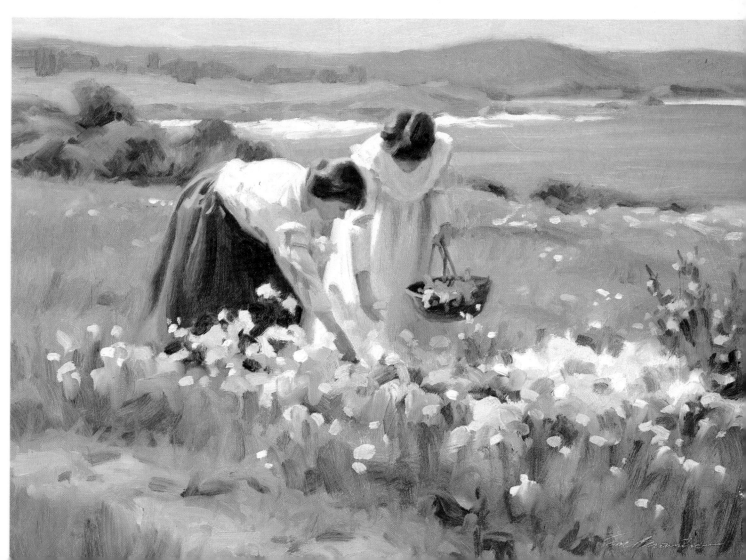

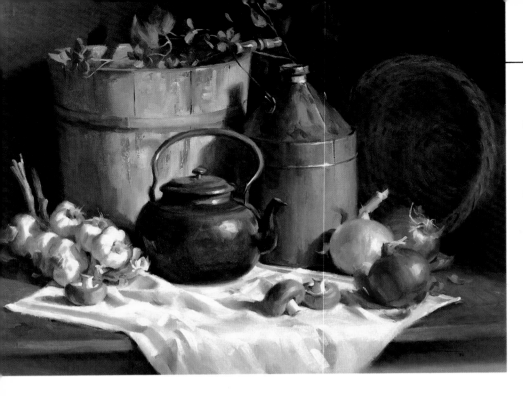

Collected Relics, *Oil on canvas, 24" × 30"*

(Left.) The contrast of values between the teapot and the bucket helps give the teapot the dominating role as the primary focal point. It creates a dark spot surrounded by the lighter values of the other objects. These other areas with their more closely related values remain secondary.

Crimson Glow, *Oil on canvas, 24" × 30"*

(Below.) Because of the massive size and dark color of the jug, it's clearly the center of interest. Even though the wooden box in the background is larger, its values and colors are more similar to the rest of the painting, thereby not attracting as much attention.

In a still life with several objects, one has to dominate while the others perhaps help to direct the eye, yet keep a more subdued role in the overall picture. As I mentioned before, this can be done with contrasting values and colors among more closely related values and hues. The former create the *primary focal point* while the latter constitute *secondary focal points*.

A more simplified way to think of your center of interest is that it should be different from other areas of the painting. This difference can be achieved in size, for instance. If most of the objects in a picture are small, a large one would certainly stand out and dominate. Likewise, a small sharp object can stand out against a lot of soft, massive objects.

Color is yet another way to make the primary focal point different from the secondary focal points. A bright, vibrant color surrounded by more subdued and grayed tones will have no trouble making its claim as the dominant point of interest in a picture.

For the past several years I've been doing a series of Santa Claus pictures specifically for greeting cards. No matter what the scene might be, Santa's bright red clothing and white beard create a center of interest that would be difficult for any other part of the picture to contest. When I combine this with contrasts of value, color and size, the viewer's eye immediately goes to Santa and is held there until curiosity allows exploration of the rest of the picture. Little elves and humorous twists usually add to the success of the paintings.

Easy Putt, *Oil on canvas, 24" x 20"*

Color is yet another way to draw attention to the center of interest. A bright, intense color surrounded by muted gray tones will surely grab your attention first.

Division of Space and Creating Balance

As I stated previously, composition is a personal choice. An arrangement pleasing to one artist might make another artist uncomfortable. So bear in mind that the examples and statements I present are based on my preferences and beliefs. Although there are no defined rules for composition, there are plenty of theories and formulas that have been tested and retested for centuries, and a lot of attention has been given to the division of space. Up to this point my discussion of composition has been centered on the importance of a dominant interest and possible ways to achieve it. Logically, once this has been determined, the next step is to decide where on the canvas it will be placed. This will determine the *division of space.*

Although there may be many possibilities for placement of the center of interest, there must be a pleasing *balance* between this and the other elements of the composition. It's easy to achieve balance through symmetry. In fact, architectural schemes and many decorative designs require symmetrical balance. However, symmetrical compositions in painting run the risk of becoming uninteresting to the viewer. Therefore, a good distribution of space is necessary to create interest for the viewer.

It must be human nature or instinct to want to place the focal point in the geometric center of a space, be

Box A is divided directly in half, and as a result is quite boring. A more interesting way to divide the space would be as in box B. Box C's space has been divided symmetrically, and again is not as interesting as box D. Boxes E and F are both interesting examples of division of space.

With the center of interest in the geometric center of the composition (right), all of the areas around it are equal and uninteresting. By moving the subject up above the center of the picture (far right), a more engaging composition is created. The area below the onion gives more support than before, and the area above no longer seems too heavy.

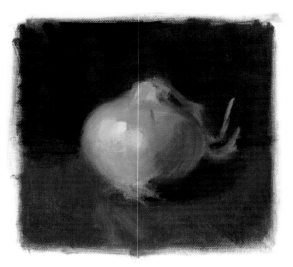

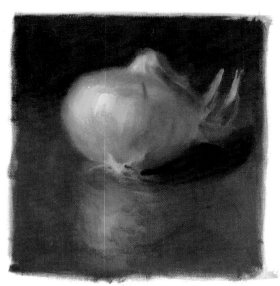

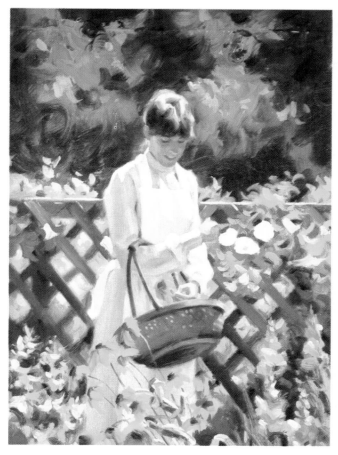

Here the center of interest has been placed in the center of the composition. This gives the feeling that the figure is slipping out of the picture, or that the area at the top is too heavy, pushing down on the figure. This is a common composition among beginning painters.

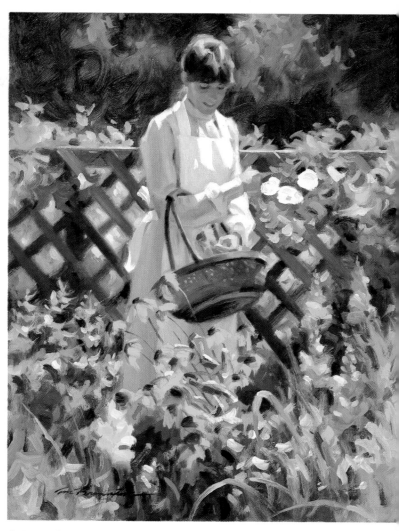

Colors of Summer, *Oil on panel, 18" × 14"*

Rather than placing the figure in the exact center of the picture, I chose to put her higher up into the aesthetic center. This gives the area below the center of interest the feeling of support.

cause it seems that nine out of ten beginning painters do it. Perhaps they associate their center of interest with the bull's eye of a target. I think it is generally accepted by most artists that placing the center of interest in the middle of the canvas creates a balance that is awfully boring and static. To me, it's hard to consider it a composition.

By simply moving the center of interest above the geometric center of the picture space, a more pleasing balance is achieved, and a composition is created. I consider this to be the aesthetic center. Now the space around the focal point is divided into areas of differing proportions. This in itself creates interest. The lower space now seems to give support to the focal point and at the same time adds weight to the bottom of the picture.

I know that these words sound like a discussion of art theory that you might hear at a gallery showing, but see for yourself (above) how the aesthetics of a picture can change along with the composition.

Even more interest can be achieved by moving the focal point from the center towards a corner. As long as the space around it seems to support the center of interest, a pleasing balance is created resulting in an interesting composition. Obviously, there are four such areas in a square or rectangle. Any one of these points is a good location for the main focal point.

Although these points that are directed out towards the corners create interest and good balance, I avoid placing my focal point too close to a border of the picture. This crowding leads to a feeling of imbalance. Unless something is added to the picture as a counterbalance, this can leave the viewer feeling uncomfortable.

Each of the spots within this rectangle is considered to be at a point of aesthetic interest, unlike the geometric center.

This figure by itself is probably too close to the left border for most people. It gives the feeling that everything is soon going to tip to the left because of the lopsided weight.

The wheelbarrow balances the composition so the figure no longer seems to have the weight to pull the picture down to the left.

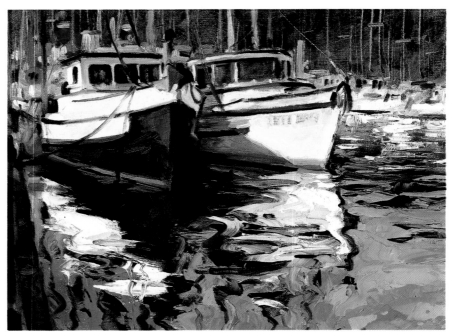

Newport Harbor, *Oil on panel, 9" × 12"*

By moving the focal point towards a corner, a more interesting composition is achieved. Imagine the picture with the boat on the left removed. A single boat in the center would simply be less interesting.

Friends and Flowers, *Oil on canvas, 16″ × 20″*

(Below.) This composition is more comfortable for me. The center of interest is well above the center line, and everything below it is of secondary interest. Here I like to establish movement and direction with whatever lies in the foreground—in this case, flowers.

Unless my painting is a landscape portraying a lot of sky, I usually don't place my center of interest below the center plane of the canvas. Along with placing the main object of interest in the absolute center of the canvas, placing it too low is a common problem with beginning students. This causes the picture to look top heavy. There are occasions that I'll balance my subject below the center line with something with enough mass and interest above. But for the most part, the space below the center line is an area I reserve for my secondary focal points of interest. I usually establish movement and direction paths in this space to give support to my main area of interest. But I'll discuss this in greater detail later.

I also don't like to see pictures that have been divided into two equal halves. Equality is never as interesting as an element with one dominant and several supporting factors.

Afternoon Tea, *Oil, 18″ × 14″*

If I had placed this figure more to the left, it would have in effect cut the picture in half, something I try not to do. By placing her more to the right and introducing the tablecloth and chair, I've created a more interesting balance.

Tangents and Overlapping

A common oversight that occasionally slips into pictures is the *tangent*. As a kid, I used to think how clever I was in photographing a friend with his palm held out to his side in such a way that it appeared he was holding some distant structure in his hand. What I thought was clever then certainly isn't desirable now when composing pictures. A false illusion is created by placing two lines that are too close together and continue along what appears to be the same plane. Another common tangent is allowing the edges of two forms to touch, so they look joined like Siamese twins.

You can see by the sketches below how the viewer could be confused as to what was intended when a tangent occurs. The best way to avoid tangents is to always try to *overlap* when placing objects in a composition. This helps eliminate any confusion for the viewer and unifies the elements in the picture. I'll discuss a little later some other important benefits of overlapping.

(Below, left.) Tangents are both common and bothersome. All of the objects in this arrangement have awkward connections to each other, known as tangents. The contour of the teapot's spout parallels the apple next to it, while the pears on the right appear to be either stuck to the teapot or holding it up. A tangent also occurs where the horizon line runs right along the top of the lid.

(Above.) Notice how all of these objects seem to be joined like Siamese twins. I try to make sure not to let tangents like this slip into my compositions.

(Left.) To better unify the elements in a composition and let objects relate visually, try to overlap objects.

How Values Control Composition

I've explained to this point the center of interest and discussed the division of space to achieve balance. Another way to consider this is in terms of *positive* and *negative space*. The defined area of the painting to which the viewer's eye is drawn can be thought of as the positive space. Therefore, the area surrounding the positive is considered negative space. If a painting is mostly light in value and the center of interest is darker, attracting the eye, it is positive. Likewise, if the painting is predominately dark, the light area that draws attention is positive while the dark area is negative.

With these contrasts of values, patterns occur. And these can be arranged at the artist's discretion for yet another way to create balance. This balance of patterns, or positive and negative spaces, is a very important consideration when composing a picture.

I need to mention there can be more than one positive area. In other words, the center of interest does not have to be the only positive area. Secondary areas of interest can be positive

*P*ositive and negative spaces should never be equal in area. One has to dominate.

as well. However, positive and negative spaces should never be equal in area. One has to dominate. Without one or the other dominating, the picture is without impact and becomes uninteresting.

In order to determine the best use

Franz and Maggie, *Oil on panel, 18" × 14"*

This picture is predominately dark. The man's shirt and the white of the dog are the positive areas of the composition.

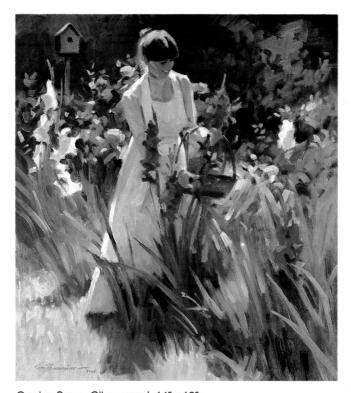

Garden Song, *Oil on panel, 14" × 12"*

Here the positive areas (the figure's apron and the white flowers) take up less area than the dark background and green foliage that make up the negative spaces. All of the positive spaces together should not equal the negative in total area. As soon as the two become equal, neither is positive or negative.

(Below.) Small composition studies can help determine the best use of patterns and division of spaces before getting into the painting itself. Planning the composition like this in the beginning can keep you from having to make changes halfway through a painting.

of patterns, many artists do small preliminary composition sketches with a pencil before starting a painting. By arranging patterns of negative and positive spaces, they can determine where the strengths and weaknesses of their compositions are before picking up a brush. The results often look like little abstract drawings, and in a sense, that's exactly what they are. It's this abstract arrangement of patterns that makes a painting interesting or boring. This practice is good planning that can keep you from having to start a painting over due to a lack of balance and interest. Remember when doing these little studies not to let the positive

spaces equal the negative.

Having discussed some of the concepts of the center of interest, positive and negative space, and the division of space, I'd like to take one or two simple subjects and explore some possibilities of composition. This should demonstrate that there is no right or wrong way to compose an idea and explain what can strengthen a chosen composition.

Kids at the beach have always been a favorite subject of mine. The expanse of the shoreline, the waves, and patterns of incoming and outgoing water all make for interesting negative space to help support the center of interest.

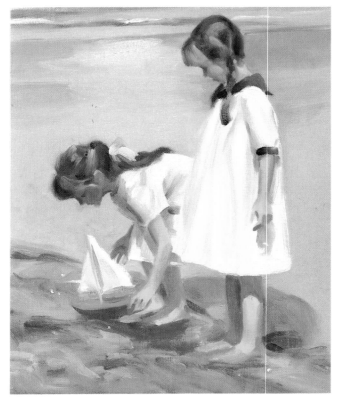

A

Any one of these three compositions would be suitable. (A) focuses on the figures. The girl on the right is balanced by the other figure and the boat. (B) lets more negative space play a part in the composition, but the girls are still fairly centered. In (C) I've moved the girls to a more aesthetic point of interest where they can be seen as a single unit. They're now balanced by the darker line made by the rippling water, which is now an area that supports the two figures.

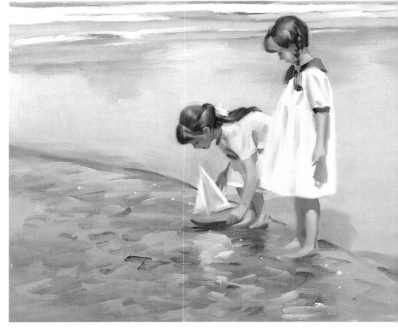

B

C

Keeping the Eye Moving

Although the idea of the center of interest is to attract attention, it's important that the supporting areas and negative spaces are inviting enough to also interest the viewer. Ideally, a painting is composed in such a way that the eye starts at the center of interest, then is directed throughout the picture, free to move out of the borders and back in again, then follows some directional lines full circle back to the original focal point. This is a form of *rhythm* that can be compared to listening to music. There's an overall melody and a rhythm that carries all the way through the song. Likewise, rhythm in a painting can help lead the viewer's eye throughout a painting, making the visual experience more enjoyable.

(Above.) This drawing shows the visual paths that the eye takes throughout the painting.

Cottage Garden, *Oil on canvas, 30″ × 40″*

I enjoy rearranging flowers in my garden scenes to add as much flow and rhythm as possible. The purple flowers leave the woman's shoulder and flow down into her basket where they become yellow, continuing to move down and into the foreground. The cottage is also full of directional lines that return the eye to the center of interest.

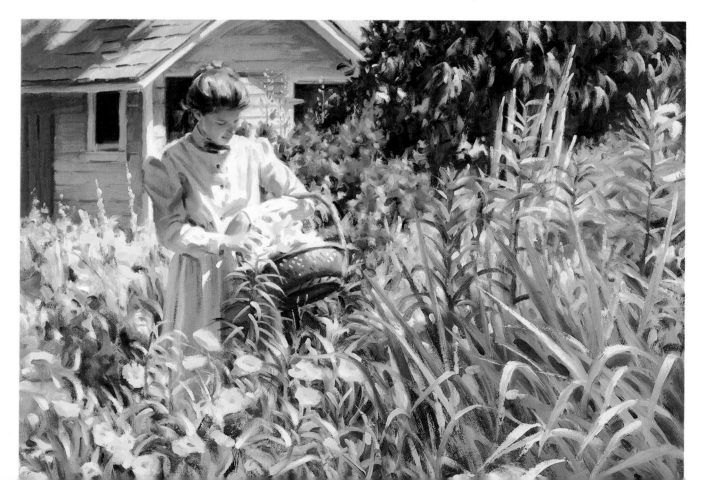

Developing rhythm in a painting can be done in several ways. Remember, you're trying to hold the viewer's eye and guide it around the painting. Natural lines of direction are created with the placement of objects in the picture area. I try to purposely place these objects and lines to either lead the eye to the center of interest or through and around it.

Repetition of shapes and forms can also provide a way to establish rhythm in a composition. When arranging these forms, avoid making them all the same size and shape or placing them equal distances from one another. Variety in shapes, sizes and placement help create rhythm and balance and avoid monotony. I also like to group objects in ways that force an asymmetrical balance. For instance, if I'm going to have onions in a still life, I'll have an odd number, say three. When placing them in the composition, I'll more than likely put two of them together and the third onion away from them.

Study for Mother's Helper, *Oil, 11" × 14"*

The porch rail helps to form a rhythm and at the same time provide directional lines for the eye to go out and back into the composition. To keep the railing from becoming too monotonous, I've thrown a shadow over parts of it to add variety. The column, butter churn and doll are placed so that the eye will continue to follow a circular path in the composition.

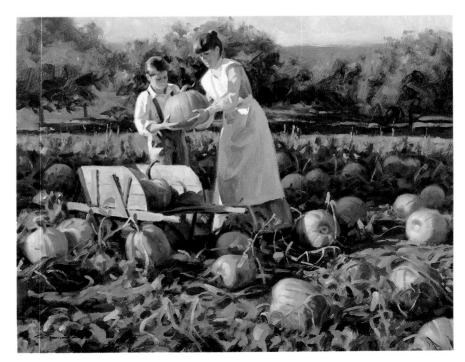

Pumpkins Pumpkins, *Oil on canvas, 18" × 24"*

Repetition of forms is another way to add rhythm to a composition. Here the pumpkins start on the left and continue across the picture down into the lower right corner. Varying sizes and shapes help add to the interest. The pumpkins in the foreground help create a directional path for the viewer's eye to follow. They help pull the eye into the composition, then lead right to the figures. Then they resume directly behind the figures and go off into the distance. This helps to unify the composition as well as add movement and rhythm.

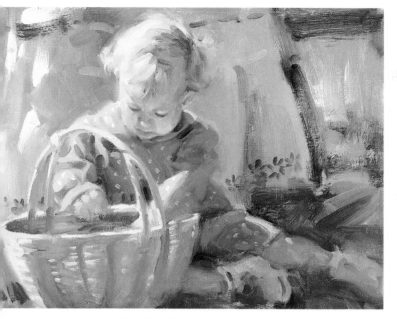

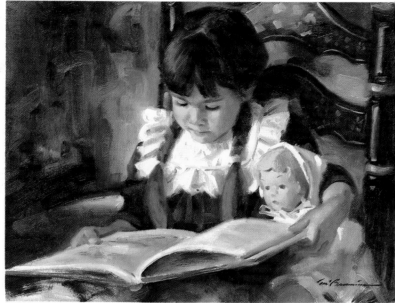

Inquisitive, *Oil, 12" × 16"*

This picture is composed mainly of soft edges. The hard edges found on the basket and around the baby's head keep the eye in those portions of the composition. Everything else is soft and loose so the eye can drift away and back to the center of interest. Crisper edges were used in the little floral patterns at the bottom of the apron to help them be more visible.

The Scholars, *Oil on panel, 12" × 16"*

The only detail I was interested in when painting this piece was around the girl's face. The further away from this point the eye travels, the less detail I included. In fact, the lower left corner contains no image at all, but is still an important part of the composition.

Edges, as I mentioned earlier, may or may not attract the eye. Since a hard edge attracts and holds the eye, this can be very useful in guiding the eye throughout the painting. These edges can be incorporated with directional lines or objects placed for the purpose of establishing rhythm.

Any one or all of these elements together can help create a path for the eye to follow. As I stated above, it's most desirable to have the eye return to the center of interest after discovering all of the other elements and less noticeable components that support it. Anytime a viewer explores the entire painting, care in composition is usually the reason. Incidentally, not every concept of composition has to be included in order for a painting to be successful, but having these concepts in the back of your mind can certainly help solve problems.

The handling of detail also plays a big part in composition. Anyone can

tell right away that I'm not particularly interested in a lot of meticulous rendering in my paintings. I strive for simplicity and fully subscribe to the old axiom that "less is more." Detail in a painting is fine, but too much of it in my opinion can kill a painting's effectiveness. If a lot of refined work is to be used, it should be limited to the center of interest. As the eye moves out away from this focal point, the amount of detail should start to diminish. The further away from the center of interest, the less detail I like to see. An area containing a lot of fussy drawing catches the eye and holds attention longer than an area with very little detail. If all areas of the painting are treated with the same amount of detail, the picture tends to become monotonous. Remember, one area needs to dominate. There are, I admit, lots of people who love to pore slowly over paintings loaded with details, not wanting to miss a single stroke. How-

ever, others prefer to let their eyes glide smoothly and freely over the painting, always returning to what first captured their attention. Then they subconsciously find another route to explore the painting. It's then they realize something different is seen each time they look at the painting. To me, that's the mark of a good composition and proper use of detail to enhance it.

The negative areas of a painting can be devoid of any subject matter or perhaps contain many objects. What's most important is that they maintain interest and hold their proper places without creating distractions from the main focal point. Backgrounds and foregrounds have to work with the main subject so it appears that it truly belongs at the center of interest. It's also desirable for them to provide some pathways for the viewer's eye to move around the painting.

Creating Depth Through Composition

Spatial depth in a picture can be controlled not only with values and temperatures, but also with the placement of the various objects or forms in a composition. The premise is that an object placed lower in the picture is going to appear closer to the viewer's eye. Subsequent objects placed higher in the picture will seem farther away. This is also the basic concept of perspective drawing, a subject that requires much more attention than the scope of this book allows.

Earlier I touched on how overlapping objects not only help avoid tangents, but also provide a path for the eye to follow. In addition, overlapping objects and forms can create a sense of depth in a composition. By continually placing one object behind another, and gradually making them smaller in size, the illusion of infinity can be created.

Size variation can also lend to the illusion of depth. Consider two objects of approximately the same size and shape — apples, for instance. If drawn the same size, they will appear to be on the same plane. But if one is drawn smaller and then elevated, it will give the impression of being farther off in the distance. By utilizing overlapping and the variation of shapes and sizes, not only can you create a sense of depth in a composition, but you also will be adding rhythm, balance and uniformity to the overall design.

The placement of objects low in the composition gives the illusion that they are closer to the viewer than objects placed higher in the picture area.

Overlapping objects can help create a sense of depth in a composition.

Because these apples are all the same size, they appear to be about the same distance from the viewer. The only indication that the center apple might be farther back is its elevation.

(Above.) Variation in size can greatly help with the illusion of depth.

(Right.) The illusion of infinity can be made by overlapping and continuing to reduce the size of objects.

Again, simplicity is an important consideration when you're composing. The eye is more attracted to complex forms and less attracted to soft and subtle areas of a picture. So backgrounds should contain fewer details and hard edges than forms that are closer in the scene. This also helps to add a feeling of depth to a design. Be-

sides, this is how the eye actually sees. Details in distant objects are difficult to see. The closer the objects become, the more details are evident. And remember that darker masses tend to recede while lighter values come forward. For simple still lifes, this light versus dark arrangement works well to convey a sense of spatial depth. But

you have to be careful not to let the values of the background compete with the values in the center of interest. Make sure that the values in your center of interest and not the background are what attract attention. And remember to confine your darkest darks to the center of interest.

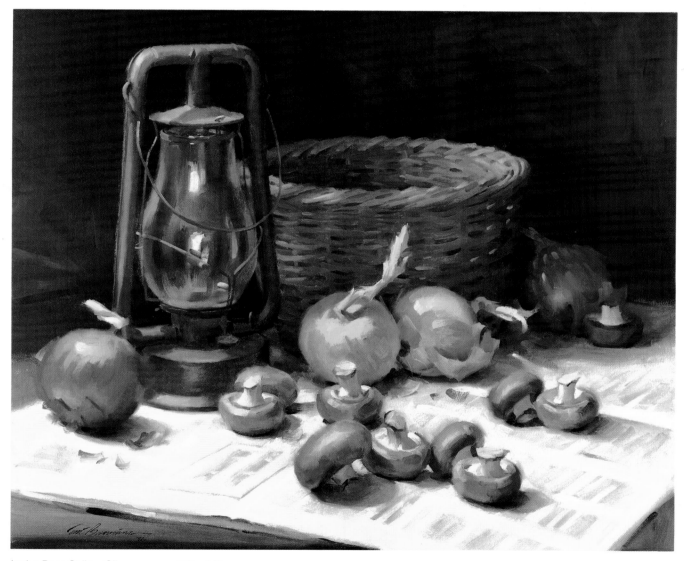

In the Root Cellar, *Oil on canvas, 20″ × 24″*

This background is extremely simple. It contains darker values of the same colors that make up the basket and lantern. It rests quietly and in no way competes with the objects in the arrangement. The newspaper in the foreground is suggestive in its treatment. Painting the actual printed words that were visible would act more as a distraction from the intended center of interest.

Setting Up a Still Life

Using the information that I've covered in this chapter, I'd like to go through the steps I generally take in setting up a still life. I'll take some simple objects and share the process of arriving at the final composition.

The first step is deciding what this painting is about. Since I don't have any particular object in mind to paint, this will be an exercise in composition. Onions or fruit generally allow me to create interesting secondary interest areas, so while at the farm where we buy our produce, I notice a box of onions that hadn't had the tops cut off yet. Back in the studio I lay them out on the table then go to the prop room and look for something to put with them. A copper kettle looks like it will fit the bill, and I put it on the table with the onions and evaluate the relationship. The kettle is so different in size and color from the onions that it dominates the relationship and leaves little doubt that it will be the center of interest.

The next thing I like to do is establish where my point of view will be. Each time I make an adjustment in the placement of objects I return to the spot where I will stand while observing and painting.

Although I can make an interesting arrangement with the onions and kettle, I'd like to see more happening in the background. So I grab an old basket and place it on the table with the other objects.

Before becoming concerned with the arrangement of the onions, I want to establish the center of interest and everything closest to it. Because of the size of the basket, it will have to sit a bit behind the kettle so it doesn't compete by blocking out part of the main object of interest. I purposely let the

The size, color and shape of the kettle make it so different from the onions that it should obviously be the center of interest.

A basket added to the grouping could make a more interesting composition.

By setting the kettle back in the shadows of the basket, it becomes an area of secondary interest while the basket dominates and gains attention. This demonstrates how lighting and the placement of objects influence a composition.

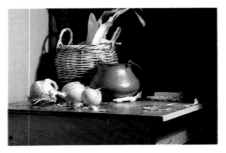

But I'd like to keep the kettle at the center of interest by positioning it in front of the basket. Here the contrast of the kettle against the basket attracts the eye. With less of the basket showing, it not only becomes less important, but it also adds depth to the composition.

kettle overlap the basket to not only maintain the center of interest, but also to create the feeling of depth in the picture. Through lighting and changing its placement, the kettle could be made less important in the composition. If it were back in the shadows of the basket, it would become less noticed and of secondary interest. It's up to me to control the arrangement. For this painting, how-

ever, I'll leave the kettle in the lime-light.

To add more height and interest to the composition, I find some dried corn husks and leaves to put in the basket. However, the direction of the corn husks goes straight up out of the composition. I suppose this would be all right, but I'd like to see them add a little more rhythm and unity to the composition, so I rearrange some of the leaves so that they flow out to the right and down. This takes up some of the negative space in the upper right portion above the kettle, and helps to strengthen the relationship of these elements. It also helps establish a circular path that the eye can take around the center of interest.

At this point I start arranging the onions. I usually start out with more than I need and begin taking away pieces. While moving them around, I'm constantly trying to be aware of tangents and too much symmetry. One thing that's very important at this point is to note the type of line the bases of all the objects form. If this line seems too straight, the composition is robbed of motion and rhythm. It becomes too static. I try to add rhythm by placing the onions in more interesting ways that help guide the eye through different areas of the painting.

When I'm finally comfortable with the placement of all the objects in the composition, I check once again the connecting patterns of shapes and shadows, possible tangents, and the general flow and balance of things. I see an area on the left side that could use a little more interest. A few more dried corn husks with a touch of bright yellow corn adds interest without being too distracting.

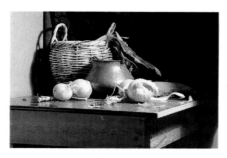

I wanted to add more unity and rhythm outside the center of interest, so I rearranged the corn leaves in the basket to flow into the negative space on the right. This helps to keep the eye from going straight up and out of the picture via the upright leaves as before.

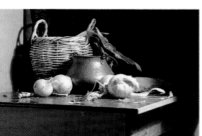

Here the onions are too symmetrically lined up with two on each side of the kettle.

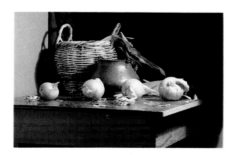

Try not to have equal spaces between objects as seen here. Can you see how boring and monotonous these onions look? Also look at the straight line made along the bases of the onions. There's no variation of line, no depth, and no interesting path for the eye to come into the picture from the bottom.

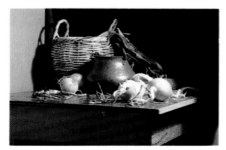

This arrangement seems to work pretty well. I let it sit for a while as I prepare my palette, always glancing at the set-up, mentally painting it as I get ready.

With this arrangement satisfactory, I go ahead and begin the painting. The total time I've spent setting this up is about thirty minutes. It's not unusual for me to spend a lot more time, sometimes half a day, arranging a few objects to my liking. At any time when I see something that bothers me, I'm free to move things around. It's just one more aspect of being in control.

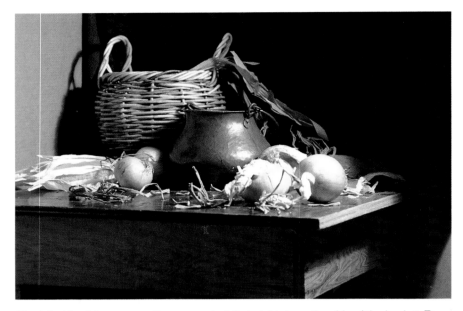

The left side of the composition seems to fall straight down the side of the basket. To break that line up, I added more corn husks with a touch of bright corn for interest. This also gives the eye another path in and out of the composition.

Lone Pine Harvest, *Oil on canvas, 18″ × 24″*

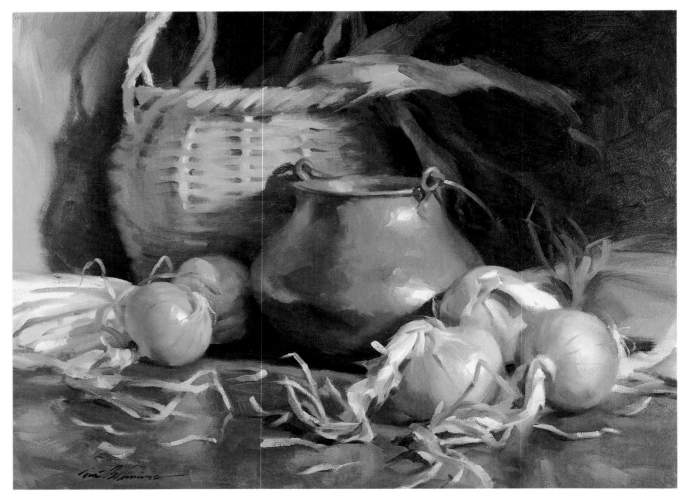

Setting Up a Scene

Setting up a scene with figures and props takes all the steps and care that I go through for a still life. Even though the area involved is much larger, the same considerations have to be taken. Obviously, each set-up is going to be different, but the basic ideas that I've explained still apply.

The idea I have for this scene is a mother bathing a baby. I'd like the mood to be warm, and would like the feeling of a mother's love to come through to the viewer. I want to set the scene in an earlier time when things were more simple, so my choice of props and costumes will make that obvious.

Since a baby's attention span is about two seconds, I'll resort to photography to capture the gestures and details I'm looking for. I've decided that the warm glow of a fire might be a fitting light source for such a scene, and I can set this up in my studio with an incandescent light shining through amber-colored cellophane.

With my idea in order, I gather the props I want to use (always having more on hand than I need) and start arranging them in various positions. Sometimes before I begin this arranging, I'll do a couple of quick pencil sketches to use as a guide. These sketches can often nail down what I'm after better than rearranging furniture and props.

Next, I have the models take their places and actually go through the motions, rather than directing particular actions. By letting them act in a natural manner, I usually pick up a movement or a gesture that hadn't occurred to me. Once I get a firm idea of what I want, then I'll ask for more specific poses and gestures that I then photograph. In this particular instance the

Quick pencil comp studies can help gel an idea before having the models take their places.

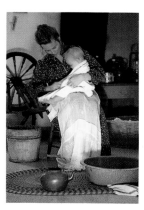

When the models take their places, I explain to them the feeling I'm after, then let them interact freely while I observe and photograph. This gives me the chance to see the actual motions that are characteristic of such a scene. I continually look for tangents, shadows that might help, and gestures from the models that might capture the moment in just the way I want. I even change models to get different movements.

lighting is so low that the slightest motions will photograph as blurs, so I take a lot of shots to compensate. Also, bits from different photos may be needed for various details of the models, the baby in particular.

At the same time I'm looking for key gestures of the models, I also scan the entire scene for such things as tangents, good places to overlap objects, and of course, shadows. Shadows can be key elements in a scene. In this case most of the background is thrown into shadow creating a dramatic center of

interest, the baby and its white towel. The contrast of light against dark forms a solid focal point with a lot of depth.

Although various arrangements would work well enough, I seem most satisfied with the baby on the mother's lap. When the mother and baby gaze at each other, the center of interest seems to be further strengthened. The viewer's eye naturally follows a path from the baby's gaze to the face of the mother. Not only does this provide a visual tie, but it also creates the emotional tie that I want.

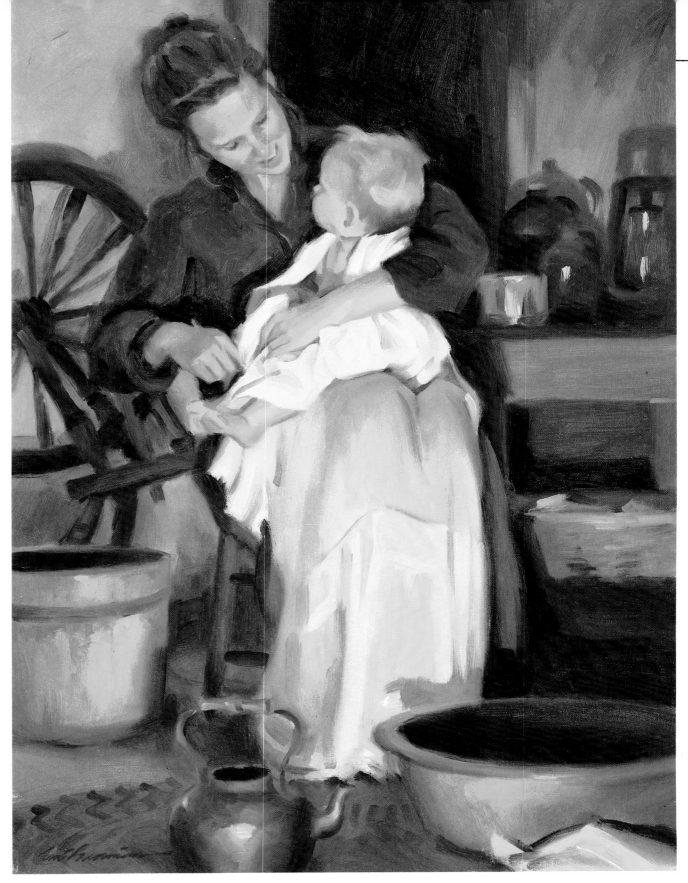

A Warm Hearth, *Oil on canvas, 20″ × 15″*

I settled on a pose with the baby on the mother's lap. The baby and the white towel are set off against the darker values of the mother's dress and background. This makes for a striking focal point. With the two making eye contact, the moment seems unified and warm. Just what I wanted.

An Eight-Step Summary of What to Look for in Composition

It's important to remember that your personal preference is important when deciding how to compose your picture. We can always find flaws in design in virtually any painting. There is no such thing as the perfect composition. What I've hoped to accomplish in this chapter is to point out and explain some valuable ideas on how to think when composing, or how to improve an existing composition.

1. Every picture should have a center of interest that dominates over other areas of the composition. This is best achieved by contrast in values, contrast in colors, or the treatment of edges.

2. Areas of secondary interest in the composition act as supporting roles. They should not detract from the main focal point. Remember, it's best if there is only one dominating area of interest in a painting.

3. The division of space to create a composition should provide a pleasing balance. Try to place the subject in the aesthetic center rather than the geometric center of the canvas.

4. Beware of undesirable tangents when composing. This problem is best solved by overlapping figures.

5. The positive area of a picture should never be equal in area to the negative space. One or the other has to dominate.

6. Rhythm is a way to keep the viewer's eye moving throughout the painting. Rhythm is created in numerous ways, such as lines of direction, placement of objects, repetition of forms, and variety in shapes and sizes.

7. Spatial depth in a picture can be controlled not only by values and temperatures, but also by the proper placement of objects and the use of overlapping.

8. Keep things simple when composing a picture. The eye is more attracted to complex forms and less attracted to soft and subtle areas of a picture.

A Sudden Breeze, *Oil, 18″×16″*

EDGES AND BRUSHWORK

Once an idea for a painting has been established, the composition figured out, and the drawing put in place, the job of getting the paint from the palette to the canvas begins. This part of the painting process helps to explain the subject and what the artist wants to convey. Along with color, it helps to carry the emotion felt by the artist. It is technique and style. And once again, edges and brushwork, like color and composition, are a personal choice. I've found that personality is reflected in the style in which a person chooses to paint. I prefer a more free style in paint application, with its blended edges and colors, to the more hard-edged appearance of a carefully rendered design. But whatever style or approach to painting you develop, it's important to remember that every edge and brushstroke should have a purpose.

Edges and Composition

I mentioned earlier the importance of allowing the viewer's eye to explore a painting in a manner controlled by the artist. Much like the driver controls a car's actions throughout traffic by accelerating, turning and braking, the artist controls the viewer's eye throughout a composition by using line, form, and their various edges.

In the chapter dealing with composition, I discussed various ways to keep your viewer interested not only in the center of interest, but the entire painting as well. I stated that it's important to keep things simple but interesting. Keep your viewer's eye moving. Find ways to unify your painting. In these ways edges are as much a part of composition as they are of drawing.

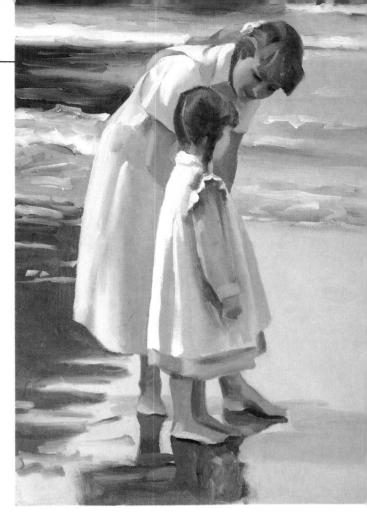

If care isn't taken where hard edges are placed, attention is drawn to too many areas, causing an unconvincing effect. You can also see that a subject that has too many hard outside edges will look like it's been cut out and pasted on to the background. Compare the edges here to the painting on page 102.

Types of Edges

Although a variety of edges happen in the course of a painting, there are basically three kinds of edges I consider while working: *hard edges, soft edges and lost edges*.

I demonstrated earlier how a hard edge attracts attention. Like a thorn, it can be sharp and demanding. I'd guess that most beginners make themselves victims of too many hard edges in a single painting—probably because it's easy to make a hard edge since it's the natural result of most brushstrokes. But without thinking about these edges and observing the subject, beginners allow the hard edges to remain, interfering with the composition. Since hard edges attract the eye, they're very useful in establishing the center of interest in a composition. They seem to cry out, "Hey, I'm important. Look at me!" But when hard edges are used exclusively throughout a painting, the viewer is not sure what

really is most important. Every part of the composition is wanting attention.

Hard edges can either accelerate the movement of the eye or stop it altogether. On the other hand, a softened edge slows the eye down and keeps it moving at a comfortable flow. A soft edge lets one area connect to another without drawing a lot of attention. A subject with hard edges all the way around it will look like it's been cut out and pasted on to the background. It doesn't properly relate to its environment because the hard edges keep it separate. The edges must allow the subject to look comfortable and connected to the surrounding areas.

Observation is the key to determining edges. It takes a lot of observing and painting from life to develop your eye in this direction. Nature doesn't really have edges, just form. So when we're faced with the task of taking what we see and transforming it into an illusion on canvas, we have to create our own edges to help make the

illusion of form seem convincing.

This is one of the problems of painting from photographs. Since the lens of a camera is made to take in anything from closeup to distant vistas, the result is a photo with everything in focus. We may want this in a photograph, but it's not the way we as humans see things. If photographic references are something you need to use, it's important to remember that painting from life as often as possible

Observation is the key to determining edges.

is also essential. You have to practice observing and applying the knowledge you gain when you use photographs for reference. Use them for the information they contain; don't copy them. If you begin to depend entirely on photographs, they will soon have more control of your painting than you do.

(Left.) The only real hard edges in this painting are found where the light actually strikes the rose petals. These edges attract the eye and hold its attention until it slowly travels down the softer stems into the vase. Compare the edges of the stems to the sharp yellow edge of the leaf in the center of the roses. Besides demanding attention, the leaf quickly moves the eye from the rose on the left to the rose on the right. By comparison, with a variety of edges the stems and the glass vase meld almost unnoticed with their environment.

(Below.) The only hard edges we see at one time are those in the area in which our eyes are focused. Everything around this area will appear soft and fuzzy. The farther away from the center of focus things are, the fuzzier they become. With this thought in mind, I looked over at the door and focused on the doorknob and painted it as I saw it. The shadows, doorjamb and everything else were very soft in appearance compared to the knob itself. This is one way to control your center of interest with the use of edges.

Let's consider at this point how the human eye does look at the world around us. Look across the room and focus on a doorknob. Notice that while looking directly at the doorknob, everything around it goes out of focus and becomes fuzzy. The farther away from the focal point things are, the fuzzier they become. This is how we see things, and this is what I try to emulate. So, at the risk of sounding too literal, it makes sense that if I'm doing a painting of a doorknob, it should contain hard edges, but everything else should be made up of soft edges.

A hard edge is relatively easy to create, but a soft edge requires a little more effort. One way to soften an edge is to drag your brush over an existing hard edge (assuming the adjacent areas

are still wet), then reverse direction of the drag two or three times until the edge becomes blurred. For this I sometimes use a bristle brush; other times I use a softer sable. Bristle brushes can produce as soft an edge as I usually need, but when I want to really blend an area, I might pick up a sable flat for the job.

How you hold the brush in your hand can make a difference in the quality of your edge. As in drawing, I suggest you get as much arm motion as possible without sacrificing control. I usually hold the brush loosely between the thumb and index finger, resting on the middle finger. This gives me plenty of control over the brush without any stiffness. The back of my hand faces the canvas on my strokes from left to right, then becomes perpendicular to the canvas on the reverse stroke. This kind of "loose control" allows for strokes that can be slow and deliberate or more spontaneous and free.

It's also important to use the length of the handle to your advantage. It is created long for a reason. If you hold the brush more towards the upper end of the handle or at the center, you'll naturally stand a comfortable distance from your canvas and easel. Holding the brush near the bristles tends to keep you too close to the painting surface. When I paint, my arm is straightened to about 135 degrees. Another way of blending an

(Right.) Dragging a brush along the border of two adjacent areas and then reversing the direction of the stroke will soften an edge. The more times you repeat the strokes, the softer the edge becomes.

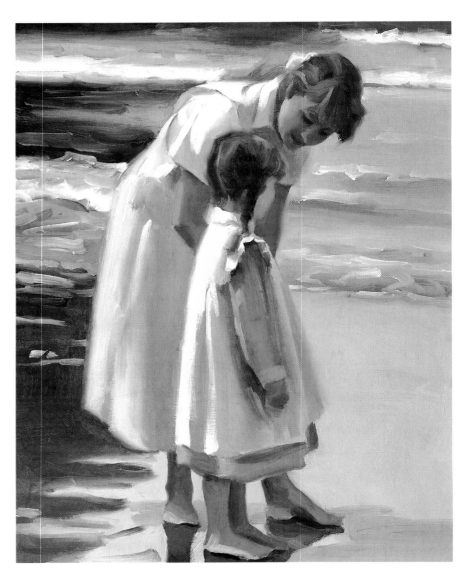

Here I've softened a lot of the edges in the picture shown on page 100. When I softened where the woman's head contacts the background, she seemed to become a little more believable. The same goes for the edges of her skirt as well as the girl's smock. The viewer becomes less distracted by these areas and can focus on the main center of interest, the heads of the two figures.

(Above left.) Zig-zag strokes produce an even more blended edge. I run my brush back and forth over an existing edge in a zig-zag manner. Then after cleaning my brush, I drag it through the zig-zag marks. This eliminates them and leaves behind a nice blended edge. (Above right.) Here I've taken a sable filbert and, from left to right, you can see where I dragged it from the dark down into the white, then from the white up into the dark. This type of stroke is good for painting such things as animal fur, hair, or perhaps distant trees.

Bristle brush Sable flat

The brush marks of a bristle brush sometimes make it difficult to view dark areas. So if the dark paint is at all thick, I like to use a sable brush to apply it. On the left I applied black paint with a bristle brush, and on the right I used a sable brush.

The Spirit of Santa, *Oil on canvas, 30″ × 24″*

There are a number of ways to depict the softness of fur. Here the trim on Santa's hat and coat was particularly long, so I dragged a sable filbert from the white out into the adjacent colors. I used plenty of wrist action in these quick but deliberate strokes. The smoke was done with a few animated strokes of a large filbert bristle brush.

edge is to use zig-zag strokes that mix the paint of the adjacent areas, then drag the brush as described above. This produces an even softer edge.

Bristle brushes can be as effective as sables when blending colors at edges; however, with thicker paint the brush marks will show. And with darker colors, light will reflect off these brush marks and make that area difficult to see as darks. So I generally use a softer brush when blending darker colors.

Another way to effectively soften an edge is by quickly dragging a brush through the existing edge and, with a flick of the wrist, lifting up the brush.

Done in one quick motion, this makes a beautiful wispy edge that looks deliberate and confident. This type of stroke can also be used to describe fur or perhaps pine trees.

My thumb is another tool that gets plenty of use while I work. When I spot a hard edge that bothers me, I usually give it a swipe with my right thumb or little finger. Some colors are more toxic than others, so keep in mind the safety factors involved when getting oil paints on your hands. I always wash thoroughly before eating. Besides, I usually have so much paint on my hands that I can't touch anything.

Girl in Pink, *1927, Walter Webster, Oil on canvas, 30" × 25"*

Here's a beautiful example of edge control with plenty of lost edges. The ballet dress becomes completely lost with the sofa, and you can see how the artist further lost edges on the girl's arm and the undersides of her legs. Notice how your attention first focuses on the area around the girl's head. That straight hard line on the pillow is what actually pulls your eye to this area and keeps pulling it back after other sections of the painting are explored.

Finding Lost Edges

As I have said, observation is the best way to determine where hard and soft edges should be painted. Their differences become easier to see when you practice painting from life. The third type of edge, the *lost edge*, is one that needs a little more discretion. Sometimes you can actually *see* their existence, but other times they are the choice of the artist. Putting lost edges in the right places can make all the difference in the world.

Lost edges go beyond soft edges as one form blends with another, losing that edge of the form completely. This helps to connect forms in a way that the eye flows from one area to another, like light flowing from one room through the doorway and into another. This effect demonstrates how important edges are to composition. They unify the elements of the painting and create motion and paths for the eye to follow.

Since it's best to keep the values in these areas closely related, I probably use lost edges most in areas of shadow. Although lost edges often occur in full light, areas painted in the light will usually contain a wider range of values and edges. Once again, you can see the relationship between edges and composition.

Creating lost edges is much the same as softening. You simply blend a little more with your brush until you can no longer see an edge. However, I use a little more wrist action — almost scrubbing — than when I'm just softening an edge, and generally use a bristle brush for the job. And again, my thumb is often called on for the task as well.

(Left.) Here I've gone one step further with the picture shown on pages 100 and 102 and created some lost edges. Areas such as that above the girl's cuff, the front of her smock, and the one along the woman's hip have been lost to let them rest better in their environment. My actual progress of a painting usually entails a lot of soft and lost edges in the beginning stages. Edges sometimes change a lot throughout the course of a painting, going from soft to hard and occasionally back to soft.

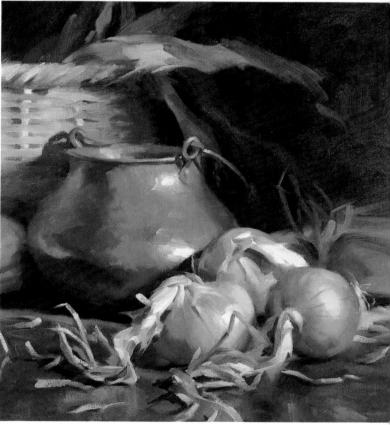

(Right.) Although lost edges can occur just about anywhere, they most often find a place in areas where the values are closely related, particularly in shadowed areas. Here the corn husks coming out of the basket become lost in the darkness of the background.

During the laying-in stage of a painting is when I usually establish where my lost edges will be. I found that not having an edge to begin with kept me from having to change edges and losing that fresh, spontaneous look. While I'm drawing in my composition, I try to identify the edges in my subject. If a form actually blends in with another form or background, I don't draw it in with a line just because I know it's there. I leave out the line and immediately have an improved composition. This is where a lot of beginners miss the boat in establishing a good start on their paintings.

A lot of interesting edges can also be created with a palette knife. If you haven't yet used a palette knife to apply paint, you really should experiment with it. There's quite an assortment of shapes and sizes of knives that lend themselves to various uses. I keep several on hand for different purposes. By dragging the knife through one color into another, interest can be added to an otherwise static area of a painting. The texture of the canvas itself can also become very useful when applying this technique. The result is an appearance that no brush can match. I strongly urge any beginning student to try doing an entire painting strictly with palette knives. It's amazing what can be learned about paint, edges, and even form. Once their uses have been explored, they can be called on at any time for just the right touch in a painting.

(Above.) It's a lot easier to create lost edges if it's done in the early stages of a painting. If two adjacent areas are very close in value or color, leave an undefined edge. If you look at your subject long and hard, you can see its entire form and will want to draw it in. Try to resist this temptation and look for these areas of lost edges.

(Right.) If you compare this stage of the painting with the one above, you can see that a lot of the lost edges remained while still others were created. It's surprising how few hard edges and accents it took to bring the picture from the lay-in to this point.

Ocean Breezes, *Oil on panel, 14″ × 14″*

I used a palette knife for the effect of light shimmering off the water. The texture of the panel helped to break up the edges and create all of the small specks of paint. I also continued into the foreground with a knife to suggest various flowers.

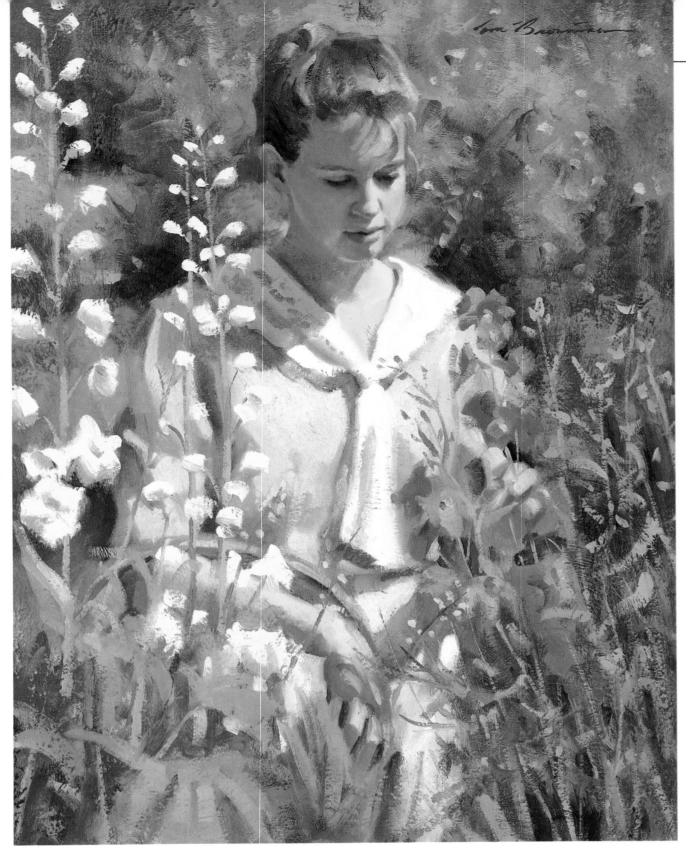

The Flower Garden, *Oil on panel, 18" x 14"*

This panel was heavily textured in all areas except where the face was to be painted. You can see in the purple flowers and the leaves of the foreground how the texture of the painting surface affected the brushstrokes.

Interesting edges tend to happen on their own when paint is applied to a textured canvas. The canvas I use most is a Belgian linen that is acrylic primed, and sometimes I give it another heavy coat of gesso that I let stand for fifteen minutes. Then before it has a chance to dry, I take a stiff brush and go over the entire surface, brushing in all directions with short and choppy strokes. This creates a texture with a lot of brush marks when the gesso dries. For painting on panels I find this texturing process necessary, since I really dislike painting on a smooth surface. This rougher texture breaks up the brushstrokes and palette knife work, producing a ragged-looking edge. To get this dry-brush effect, the paint should not be thinned with any type of painting medium.

Values and Edges

It's also important to consider the relationships that values have with edges. Controlling values, as we know, is important. Equally important is the control of edges. And there are times when values can be used with edges to control the viewer's eye.

As I've already discussed, hard edges should be used in areas of high interest to focus attention, while soft edges let the eye move along more easily until it comes to another hard edge. Yet there will be times that you want a hard edge, but not the attention that normally goes along with it. The way to deal with this is to closely relate the values of the two areas where the edge occurs.

Likewise, if you must use a soft edge but want attention drawn to that area, you can increase the value contrast of the two adjacent areas. On the other hand, if you must have contrasting values but don't desire a lot of attention, simply soften the edge.

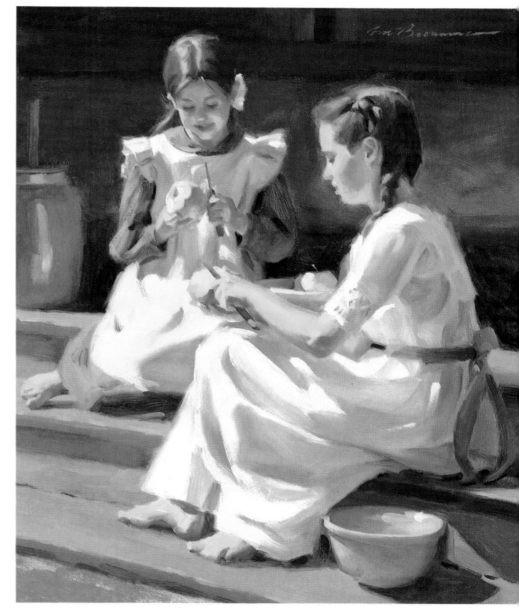

Kristal and Lillian, *Oil on panel, 14″ × 12″*

Hard edges don't have to draw attention as long as the two areas creating the edge are close in value. Here the handle on the butter churn and the smaller girl's arm in shadow are both fairly hard-edged, but because of the values of the area next to them, they stay quietly in their places. And although the white apron and dress are not the center of interest, they're close to it. They obviously stand out because of the dark values of the background; however, I downplay this by softening the edges. With the exception of the lower girl's knee, nearly all of the white-against-dark relationships are handled with soft edges.

Edges Can Make a Difference

Rhythm and interest are greatly increased by the variation of edges throughout a picture. We've seen that a picture painted exclusively with hard edges isn't very convincing, but the same can be said for a composition composed of only soft edges. The en-

Rhythm and interest are greatly increased by the variation of edges throughout a picture.

tire painting would seem to be out of focus, not to mention monotonous. It's exciting to see a painting that has an array of edges. To follow the hard edge of a form that suddenly becomes lost only to be picked up again by another hard edge really stimulates the eye and keeps it moving. If there's something that's not quite convincing about your painting, check your edges to see that they have enough variation. It can make a big difference.

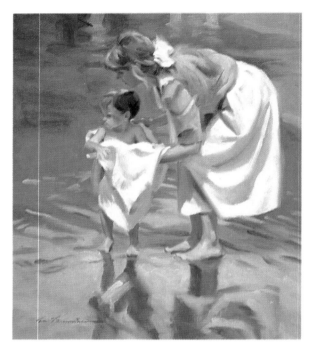

An Assuring Word, *Oil on canvas, 18″ × 16″*

A good variety of edges can help keep a painting alive and interesting. I've tried here to use edges to help guide the viewer's eye around the figures at a pace that varies. Remember, a hard edge can either stop the eye altogether or accelerate its movement, while soft and lost edges let the eye glide smoothly and drift.

More About Brushwork

Although edges can be considered a matter of brushwork, by itself brushwork is an effective way to create excitement, convey emotion or even describe your subject. Brushwork is often considered technique, so you often hear of an artist having "good" or "clever" technique. But whether it's clever or not, brushwork can be used to explain the character of a subject and convey its texture and substance.

Two different words are commonly used to describe an artist's style of brushwork: *loose* or *tight*. Quite often, tight brushwork is not easily de-tected. In other words, you don't see the brushstrokes. Instead, a lot of detail usually describes the subject. This isn't to say the artist hasn't employed his knowledge of values, color, etc. And it's a foregone conclusion that a large portion of the public prefers highly detailed paintings. Many remarkable and fine paintings have been executed in this tight style, all containing proper use of the important elements of painting. When a highly detailed painting is done properly, I congratulate the artist for the patience and determination required for such work. I think it says something for the character of the artist and perhaps reflects a bit of his or her personality. I know that I don't have the patience

Peaches and Brass, *Oil on canvas, 24″ × 30″*

Although at first this painting seems to contain a lot of nit-picky detail, a closer look reveals the brushwork I used to try to achieve this illusion. For me, this is still pretty detailed.

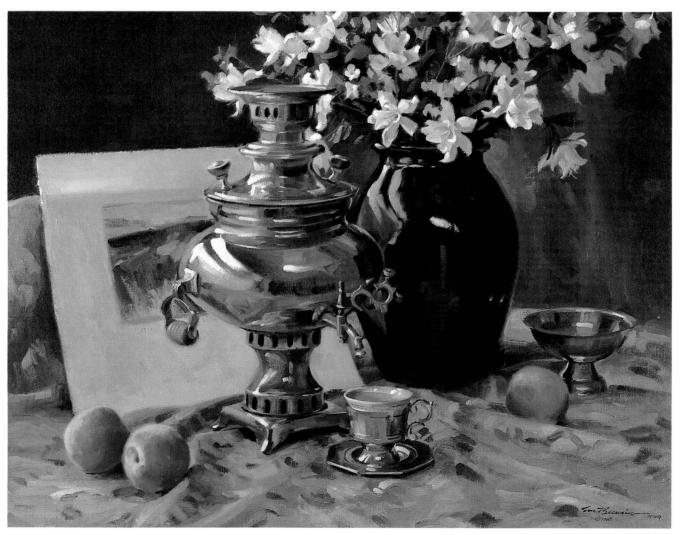

Spring Lilacs, *Oil on canvas, 24" × 22"*

After a friend brought in this bunch of lilacs, I set aside the picture I was working on so I could paint them. I considered it to be an exercise, so I gave myself three hours to complete it. The result was a lot of descriptive brushwork and a loose-looking painting with a lot of energy.

needed for hours and hours of detailed work, so I leave it to those who do. And although I can appreciate a lot of paintings that are painted in a tight and detailed style, the one thing they lack in my judgment is the excitement of *descriptive* and *suggestive* brushwork. This is what many artists refer to as "loose" or "expressive" brushwork.

Although a highly detailed painting might have everything rendered to the point that there's nothing left to the viewer's imagination, I firmly believe that it is no more convincing than a painting executed with fluid and descriptive brushwork. It is, after all, the use of values, color and drawing that create the sense of realism, not detail. If viewers are allowed to join in the painting process by using their imagi-

nation to fill in any portion of the painting that might seem unfinished, then the painting can become in a sense very real.

With the use of sounds, old radio programs helped listeners fill in with their minds what their eyes couldn't see. And moviemakers that omit certain vivid details in a steamy love scene or a frightening moment purposely leave these things to the imagination of the viewer. This creates involvement by the audience and, as a result, they sense pleasure or excitement. Viewer participation is what I like to see happen with painting as well. I much prefer a painting in which the artist creates the illusion of reality by suggestion, not by documenting verbatim nature's every detail.

How Brushwork Describes

For me, a lot of the fun in painting comes from observing my subject and determining what brushstroke will best describe what I see. It's exciting when I'm successful at finding the characteristic of something and conveying it in as few strokes as possible. If it's exciting for me, it's usually exciting for the viewer as well. So, as artists, how do we go about describing what we see without spelling out every specific detail? Observing the subject and zeroing in on its most noticeable characteristics is a start. Consider for a minute the job of political cartoonists. They're caricaturists. They pick out the features of a person that are most noticeable and they exaggerate them. With a few lines they're able to leave little doubt about who they've drawn. I use the same approach when observing before painting. I look for what best characterizes my subject by asking myself, "What makes this subject or its surface different and particular?"

Compare in this detail the brushwork I used to describe the upturned sod with that used to suggest the grass around the horses. You can see how my brush followed the planes of the sod, emulating a characteristic. By comparison, my strokes were vertical to suggest the growing habit of grass.

Descriptive brushwork was a major consideration before starting this small painting. I used horizontal strokes to suggest both the water and the white foam, but followed the contour of rocks to suggest their form.

Let's take a common object and study its character for a moment. An empty mason jar will do. It has a particular shape, being a cylinder. It's made of transparent glass, therefore its surface is highly reflective. And the top has a spiraling ridge used to screw on a cap. These are all qualities that help to describe the object. So how can we convey these qualities not with words, but with paint and a brush?

While mixing the proper colors and values that I see, I look at the jar as if it had already been painted, and I were about to emulate this painting's brushstrokes. I notice there will be a lot of vertical strokes that best characterize both the shape and surface of the jar. Being fairly transparent, its form doesn't reveal a shadowed side, so the outline of the jar is important and needs to be evident, but only where it's most noticeable. Remember, the jar has form but no edges, so as the outline of the form goes around and out of view, my edges will go from soft to lost.

Perhaps the most descriptive characteristic of the jar that reveals a lot about its surface is the highlight. Its placement helps to verify both the light source and the shape of the jar. I study the character of the highlight to see if it's hard-edged, soft or maybe both, and with fairly thick paint and one or two strokes, I put it in place. Then I stand back to see if it properly reads as a highlight and not a white sticker on the jar. Even though the highlight is most noticeable, I save it for last. Not only do I want to make sure the rest of the jar is correct before adding a highlight, I like to think of it as my "reward."

I wish I had the room to demonstrate a hundred examples of how brushwork can describe a subject. A jar is obviously one object in a world filled with things of every imaginable shape and surface. But you have to approach painting any subject in the same manner as with the jar. Its character should fall into place if you first ask yourself what stands out about your subject and what brushstrokes will best describe it. Then go for it.

Not only do objects and things of substance need to be observed and analyzed, but also lighting, weather conditions, even emotions, might need to be implied in a painting. As with objects, I try to assess these the moment that I'm about to paint and ask similar questions, such as "What makes the character of this moment different and outstanding?" The differences between a rainy day and a sunny day are obvious, but subtle differences also may exist, say when a cooling breeze comes up to change the mood of the moment. Again, observation is the key. If you paint what's important in your observations, what you feel will come out in the painting as well.

Soft edges

Single brushstrokes

Hard edges and contrast

Circular strokes

Circular brushstrokes help describe the grapes. Notice how most of the grapes are indistinct and read as a mass. Single brushstrokes suggest individual leaves. Hard edges and contrast draw attention to the white rose, while soft edges and closely related values help play down the pink rose on the left. Highlights on the grapes, apples and pitcher describe their shiny surfaces.

An Exercise on Descriptive Brushwork

A good exercise is to take an object such as a jar, and pinpoint its most notable features. Paint it, then set that painting aside and begin a second study. On the second try, simplify by giving yourself less time and using fewer strokes. Do a third study, simplifying further with even less time and fewer strokes. Continue by decreasing the time you allow yourself until you can establish your subject with just a few brushstrokes. You'll be surprised how much you can suggest with so little and still capture the essence of the subject.

The purpose of this exercise is to find the brushstrokes that are the most descriptive and expressive. The less time you give yourself, the quicker you'll spot what's important. The result is more descriptive brushwork that is strong and meaningful. I can almost guarantee that if you devote just an hour each day to some of these suggested exercises, you'll see a vast improvement in your work over a short period of time. The best decision I ever made as an artist is to put effort into continued improvement. It's not always easy to squeeze an hour or two of practice into an already busy schedule, but it's really worthwhile, if not necessary.

TWENTY MINUTES

After identifying the shape, colors and values necessary, twenty minutes was enough time to establish everything that best describes a jar of pickled peppers. You can easily see the individual strokes I used for these descriptions.

TEN MINUTES

I cut my time in half to ten minutes, and although I was at this point familiar with the jar's characteristics, I still had to observe before making my strokes. You can see how deliberate each of the strokes was, as you can just about count every one I made.

FIVE MINUTES

With just five minutes I could only go for the few elements of my subject that best described it. The approximate shape, colors and highlights seem to reveal the most about it. From here you can try capturing your subject in one or two minutes and still come out with a recognizable subject. This exercise is great for developing both speed and simplicity in your work.

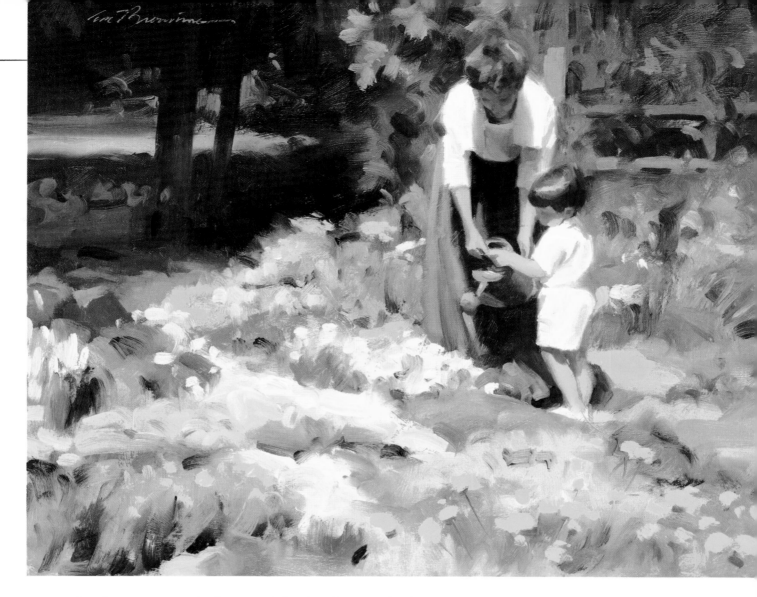

Using larger brushes on this small 11" × 14" painting kept me from getting into things such as leaves, flower petals and intricate details. Instead, I stayed focused on capturing the impression of warm light falling on two figures in a rock garden.

Another thing to try periodically is painting a small picture with larger brushes. For example, use a 9" × 12" surface and nos. 4 through 8 bristle filberts. This forces you to choose strokes that help describe the form and character of an object. It also helps you delete unnecessary detail and get right to the heart of your subject.

This brings up another problem that a lot of students don't think about. The size of your brushes should be in proportion to the size of your canvas. In other words, no. 2 or 4 brushes that work very well on small paintings and detail work are not the brushes you should use on a large canvas. If you do a small study that you'd like to do as a larger painting, you'll have to use larger brushes if you hope to achieve a similar effect. When I see painters try to cover a 24" × 30" canvas

with brushes that I use for details, I usually make some unsolicited comment, and in return get a raised eyebrow or worse. But at least I feel better.

The size of your brushes should be in proportion to the size of your canvas.

Before we go on to the following demonstration, I want to urge you to seek out those artists whose work you most admire. Whether in museums, galleries or books, find examples of their paintings. Examine their edges and brushwork. Learn as much as you can from a variety of artists and styles, then take what you want and apply it in your own work. It's worth the effort.

DEMONSTRATION
Using Descriptive Edges and Brushwork

For this demonstration I'll use the various types of edges I've discussed in this chapter and explain how the brushwork both describes the subject and helps establish a mood. Since creative edges are the point, I'll use a maximum amount of interpretation of my subject. I will also show how photographic references can be used without fear of the painting duplicating the photo. This provides a fun opportunity to let my imagination and creativity have free reign.

Step 1

Indian camps in winter fascinate me. The way the struggle for survival comes across with such pristine beauty is intriguing. I'd like to create a mood of warmth and serenity in a scene that reflects this culture's daily routine of being one with nature.

With a mixture of yellow ochre and cobalt violet, I begin to establish the forms of the tepees and the shadows that make up the composition and its patterns. I let lost edges on the left sides of both structures remain to ensure the tepees will fit comfortably in the scene. I also let the snow run into the bottom of the closer tepee where it's in shadow. See how this tepee already sits comfortably in the snow compared to the distant one.

Step 2

Now I begin to lay in color and better define the forms and structures of the tepees. To describe the softness and beauty of a snowy scene, I'm using lots of soft and lost edges. At this point almost everything seems out of focus. I'm reserving the use of hard edges until my center of interest is further developed.

This is my photo of the subject I'll be painting. I want to create a particular mood in my painting, a mood that doesn't exist in the photo. Therefore, the only information I really need from the photo is how the light falls on the tepees and how they're structured.

Step 3

I try to use plenty of paint to give the snow more weight and substance. To keep it from looking perfectly flat and smooth, I vary the values and the direction of my strokes. I also keep the transition of light into shade soft to avoid any unwanted attraction. After softening the right diagonal edge of the tepee, I add some branches and dark areas of contrast on its left side. Now things are at a point that I'm doing nothing but altering edges, colors and drawing to bring the center of interest properly into focus.

Detail

Here you can see where the hard edges have been placed, strategically, yet subtly. There are still a lot of lost and soft edges that exist, particularly in the trees and smoke. You can also see how very little detail is needed to capture the essence of trees entering the winter cycle. The texture of the panel's surface helps in this effect and is evident in the trees to the right of the tepee.

Friendly Fires, *Oil on panel, 14" × 18"*

Finish

In this last stage of adjustments, I darken and cool off the shadowed side of the tepees and the clump of trees between them. The absence of any life forms didn't suit me, so I added the figure as an afterthought. Notice how the focal point now shifts away from the tepee to the figure. Although the edges of the figure are mostly soft and broken, the contrast of values it creates makes the tepees of secondary interest. I haven't changed the mood of the scene, just the focal point. These kinds of decisions are a big part of what keeps painting interesting for me.

An Eight-Step Summary to Understanding Edges and Brushwork

1. The artist should control the viewer's eye throughout a composition with a variety of edges on both line and form. This is why edges are so important to composition.

2. There are basically three kinds of edges to consider in a painting: hard, soft and lost edges. Hard edges can either accelerate the movement of the eye or stop it altogether. Soft edges slow the eye down to a more relaxed and steady pace. Lost edges help connect forms so that the eye flows from one area to another.

3. Observation is the key to determining what edges to use. Edges can always be altered at your discretion to help the rhythm and composition of the painting.

4. If you use photographic references a lot, interpret, don't copy. Remember, it's important to also paint from life as often as possible. The practice of observation is essential so it stays with you at all times.

5. Use a variety of edges in your painting. A picture made up of one type of edge becomes monotonous and quickly loses the viewer's interest.

6. It is not detail but the use of values, color and drawing that create the sense of realism. Use these elements to *suggest* detail. Leave something to the viewer's imagination so he can get involved in the painting.

7. Let your brushwork describe the characteristics of your subject. Focus on what makes one subject different from the other elements in the painting.

8. To develop brushwork a good exercise is to give yourself a very limited amount of time to paint a simple subject. Then allow yourself even less time to paint it a second time. Continue decreasing the time you allow yourself until you're down to establishing your subject with just a few strokes. This will not only increase your confidence, but also reinforce your ability to zero in on the essential elements of your subject and choose the brushstrokes that best describe it.

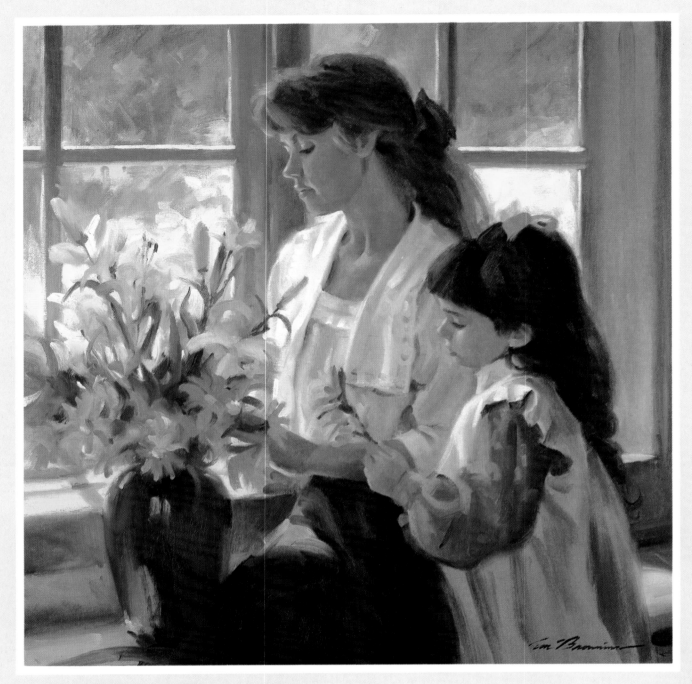

Morning Bouquet, *Oil on canvas, 20" × 20"*

APPLYING WHAT WE KNOW

When we read or hear about some concept or practice that sounds like the perfect cure for a painting problem, we often forget about it until we run across it again. Over the years I've tried to concentrate on applying good ideas that work until they become habit. Helpful theories do no good at all unless they're practiced.

In this final chapter I want to give visual testimony to the effectiveness of the information I've presented. In previous chapters I've shared with you things that have taken me a lot of time to understand and learn to apply. I keep no secrets, so I'll point out as much as I can just why I make the decisions I do. Take anything that seems helpful to you, and remember to apply it. That's the only way it will remain of any use.

DEMONSTRATION
Painting People on a Warm, Sunny Day

Step 1

I first toned my canvas with a very diluted wash of yellow ochre and viridian. It dried very light, yet dark enough to let whites stand out on it. Using the same two colors, I drew in the placement of the two figures and a few lines where the background would take shape. You can see that I was not too concerned about accuracy, since I continue to draw throughout the course of any painting. Nor was I interested in doing a comprehensive drawing before starting. This first step was to establish the composition and a few key areas of shadow. These shadowed areas could have been closer to their final values, but they really only serve as a starting place for patterns that will later contain a lot more information about the light source and the form itself.

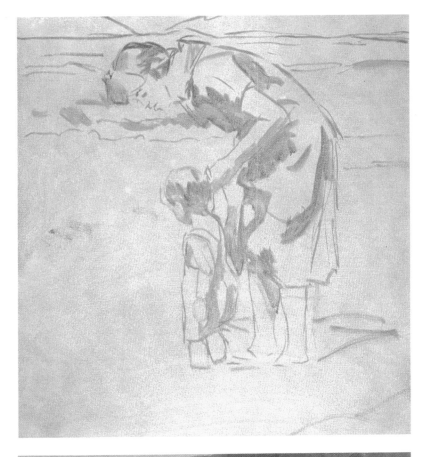

Step 2

I really don't have any particular formula for where to start painting. In this case I decided to begin with the area that will contain the strongest contrast. Because this contrast will attract the viewer's eye first, I wanted to begin constructing a convincing head. After I established the form's approximate values and colors, I quickly began putting colors and shapes into the areas around the head to give it something to relate to.

It's in this stage of the painting that I began to establish a very key element to this picture: warm sunlight. My values had to relate properly, and temperatures had to play their parts in order for the effect of a sunny day to be convincing. So as I was painting the mother's head, I kept thinking about the effect of warm light from the sun, cool light from the sky, reflected light, and shadow temperatures.

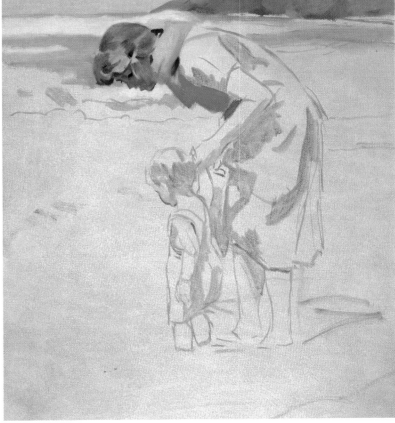

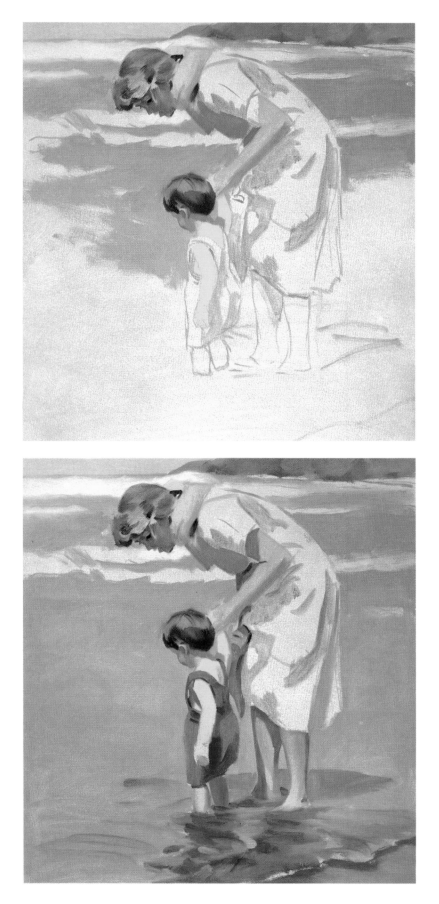

Step 3

Two simple values were used to begin creating form in the mother's arm. With the same colors, yellow ochre, cadmium red light and cadmium yellow, I began establishing skin tones in the boy. As soon as the boy's head was roughed in, I began painting the water around it not only to give the head some soft edges right away, but also to have wet paint for controlling edges later. Although the water was blue from the blue of the sky, I didn't want it to appear cold. So I used a mixture of cobalt blue, ivory black, yellow ochre and white. This paint is basically an underpainting that's not too thick at this point, but certainly thicker than a wash. This stayed wet for the duration of the painting, so I could blend colors into it right up to the end.

Step 4

The boy was actually wearing red, but I debated whether I might run the risk of creating too "loud" a statement with such an intense and saturated color. Although I often take the liberty of changing a color for a painting, I decided to go ahead and try the red. Then I stood back and could see that the viewer's eye would go back and forth from the boy to the mother's head, which in this case is just fine.

I finished laying in the water and established the legs, using two values. The dark areas in the water below the figures represent reflections. While painting such reflections, I never paint exactly what's there, but try to capture the character of reflections in water. With a mixture of yellow ochre, viridian and a touch of cadmium red, I laid down some descriptive brushstrokes that would establish not a mirrored image of the figures, but a subtle area of interest. At this point I could see exactly where the painting was going. I could now easily relate values and colors to one another for appropriate changes and alterations.

Step 5

Here I concentrated on bringing the mother's head up to a nearly completed state. It turned out that the initial rough-in was close enough that I didn't really have to do a lot to it.

I painted the hair with various combinations of yellow ochre, burnt sienna, viridian, cobalt violet and titanium white. I used a bristle flat almost exclusively for the job. In the face I just added a little more contrast by darkening it with a warm mixture of yellow ochre, cadmium orange and viridian. Her profile was shaped and altered by chiseling into the face with colors from the background.

I also worked a little more on the water and waves around the head. Again, I stopped short of actually finishing these areas.

Step 6

I could see that I wanted the value of the water to come up a bit and appear a bit warmer. Here you can see how I go about making sure the figure fits into its environment. I made a mixture of paint using the same colors as before, just different proportions. I brushed on some of this color into the water to the right of the figure. It lightened the water about two values. You can see the difference in values where I brushed on paint down the side of the skirt. At that point I began painting in areas of the skirt that are adjacent to the background. I wanted to achieve the proper value relationship and at the same time create some soft and lost edges that let the figure look as though it were truly a part of the scene, rather than being cut out and pasted on.

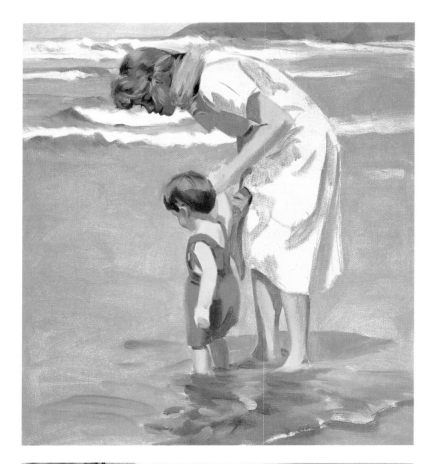

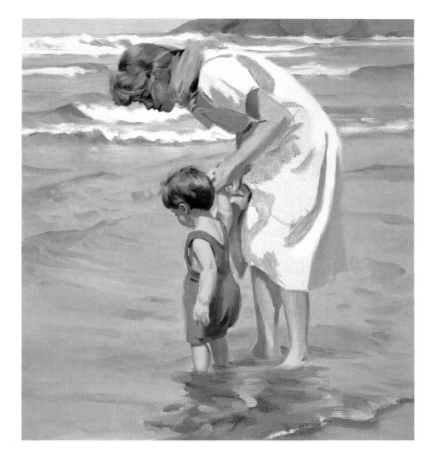

Step 7

I continued painting the surrounding waters, correcting values, changing temperatures, and adding accents that suggest movement. I added warm reflections to accentuate the effect of the sun on the water. You can see them below the wave between the two heads.

Still thinking "sunny day," I painted back into the boy. For the proper effect, I had to darken the overall tones of his skin. Just because something is sunlit, don't be fooled into thinking that the lighter you paint it the more convincing it will look. Quite often it's just the opposite. Remember that the subject is relative to everything around it. In this case the skin had to be darkened a couple of values to let the highlight areas read properly.

I went on to create more convincing forms of his arms and back. Then I took the head to a level that was about as finished as that of the mother, darkening shadows and modeling the hair.

Step 8

To paint the dress, I decided on three basic values: a dark for the shadows, a light for the overall dress, and the lightest value for those areas lit most directly by the sun. (This white is also the brightest and lightest value in the whole painting.)

The color mixture for the shadowed areas was the same as the water, but again, different proportions. Temperatures were always kept in mind. I painted those areas that faced the sky with a cool blue, while using warm blues and yellows for parts of the dress that faced downward, reflecting the warm colors from below.

I broke the lighted part of the dress into two values. It's only one or two values darker than the lightest value, but the difference is important. Otherwise, the whole dress would look flat.

Step 9

To bring the dress closer to being finished, I painted the lightest areas, working edges where light meets shadow, creating a variety of transitions. Another way of doing this might be to paint in the entire dress with lighter values, then painting the shadows into the wet paint. I do this a lot, with some really subtle and satisfying results.

I then went back to the mother's arm, adding thicker paint and defining the form. I suggested some reflected light under the forearm, which to my surprise was barely noticeable, but I knew it had to be there. Emphasizing this gave a round form to the arm, and made it a little more convincing.

Step 10

With most areas nearing completion, I wanted to work more on the water in the foreground. With alternating strokes and variations of values and color, I tried to capture the appearance of a small wave washing onto the sand. By comparison the little white sparkles in this small splash of water show how dark the white foam was actually painted.

With mostly vertical strokes, I finished the mother's legs, careful not to get any values lighter than those areas of her feet facing the sun.

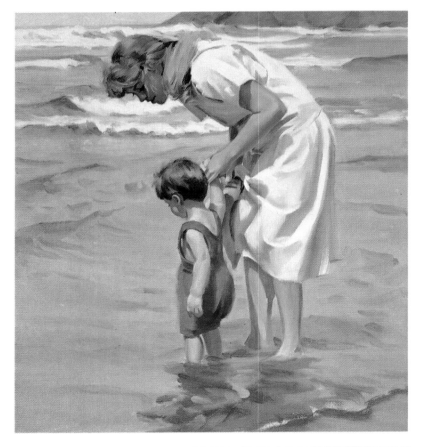

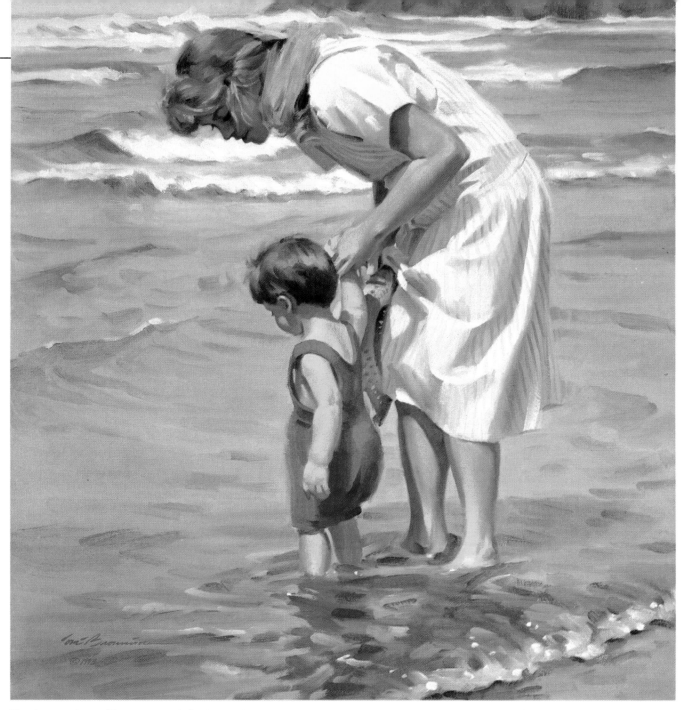

First Impressions, *Oil on canvas, 24" × 22"*

Finish

I began this final stage of the painting with the decision to add small stripes to the mother's dress, which just seemed too "blah" to me. I chose pink simply because it matched the pink bow in her hair.

I then added some variety to the distant rocks. Additional strokes of paint over the water and waves gave them more texture and interest.

The sky seemed a little too cool, and the value was too similar to the water, so I lightened it up with a warm mixture of cadmium yellow light and white. This blended nicely into the existing paint that was still wet.

The addition of a few strokes to the straw hat in the mother's hand helped make it more obvious. After a few drawing corrections in her face, I set down my brushes for the last time. Another artist might have wanted to take things a lot further, but for me, the statement was complete. If I were to continue on, I would probably end up with a painting that appeared overworked. If I were unsatisfied with a painting at this point, it would be best to start over and make different decisions from the beginning. After all, making those decisions is where the challenge and fun lies in painting.

DEMONSTRATION
Still Life — Shadows Imply the Character of Form

Preliminaries

In setting up this still life, I followed the same procedures that I described earlier in the book. In this case I wanted the theme to center around an old wooden carving that I borrowed from a friend. The other items came from my prop room.

After assembling the items on the table and turning on a strong *single light source*, I began arranging and rearranging all the objects until I came up with a composition that suited me. Then I played around with the light, moving it up and down to see what kind of shadows and patterns I could come up with. When I was satisfied, I began setting up my palette. The colors I chose were burnt sienna, cobalt blue, viridian green, yellow ochre, alizarin crimson, vermilion, cadmium red light, cadmium yellow medium, ivory black and titanium white. I then took a few minutes to study the setup, made a few last-minute adjustments, and tried to visualize what I was looking at as though it were a completed painting. This helps me to get a sense of what to aim for other than an exact copy of what sits before me.

Step 1

With viridian, burnt sienna and thinner, I first toned my canvas. I then established my composition with a combination of line drawing and shadow patterns. These shadow patterns not only help to situate the objects in their places, but also give me a reading of how the objects relate to each other. The variations in values give me a starting point and keep me moving in the right direction.

Step 2

I next established the form of the wooden figure with light, shadow *and* color. This was easier and less time-consuming than laying it in with values alone. Once the form of the figure had evolved, I could see that without the rest of the lay-in complete, it was difficult to judge the figure's actual role in the entire picture.

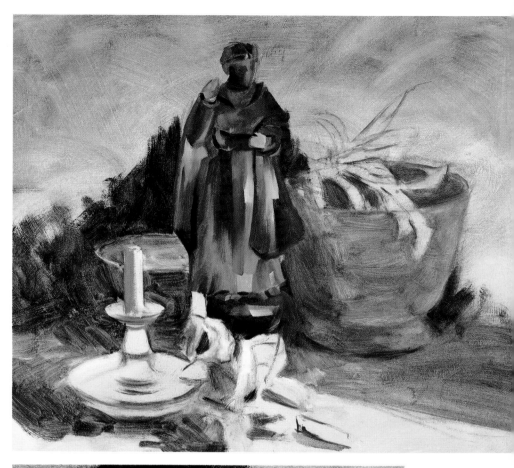

Step 3

I darkened the background adjacent to the left side of the figure to develop a more accurate relationship between the two. For this I used a mixture of burnt sienna, blue and black. Here you can see how a more accurate value in the background reveals what is actually going on in the figure. Compare this detail with the previous stage.

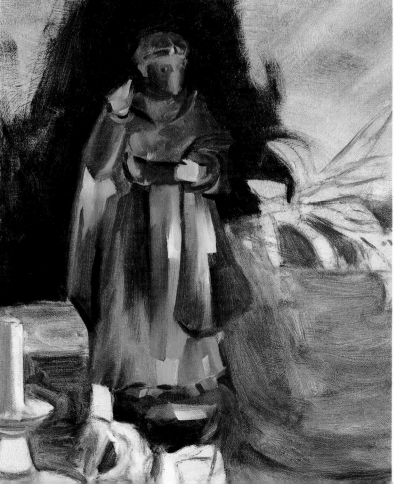

Step 4

At this point I wanted to get the rest of the picture established, always drawing, whether brushing in the background or redefining the forms.

I filled in the rest of the background and immediately suggested the decorative leaves that appeared on the material. At this point I wasn't concerned how finished these suggestions appeared; I just wanted them in place. I then blocked in the candle holder and foreground.

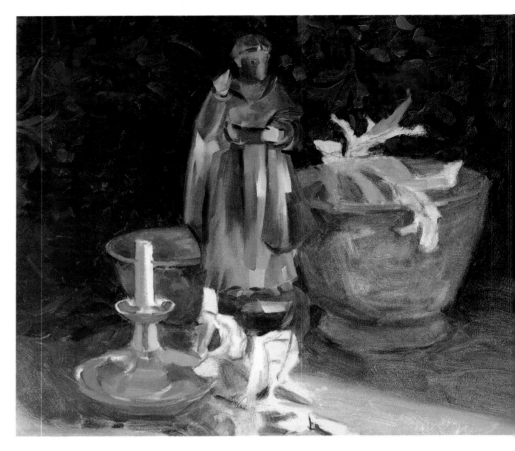

Step 5

In this stage I concentrated on the flowers. I first created the petals and areas in shadow. With cobalt blue, black, white, and a touch of yellow ochre for warmth, I blocked in these areas with just a few strokes. Again, accuracy was not a concern at this point.

I then applied the areas in light to get a proper relationship of values. I proceeded to bring the flowers to a nearly completed stage, refining the drawing and edges at the same time.

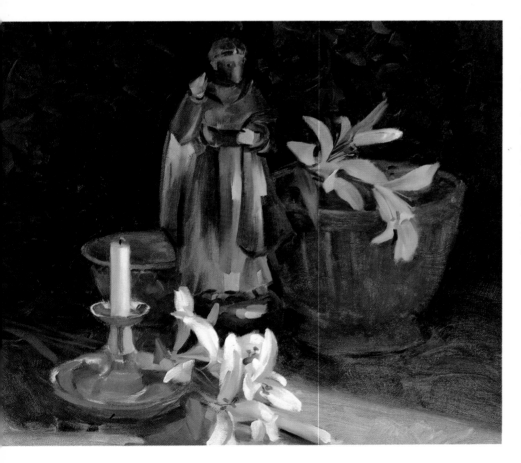

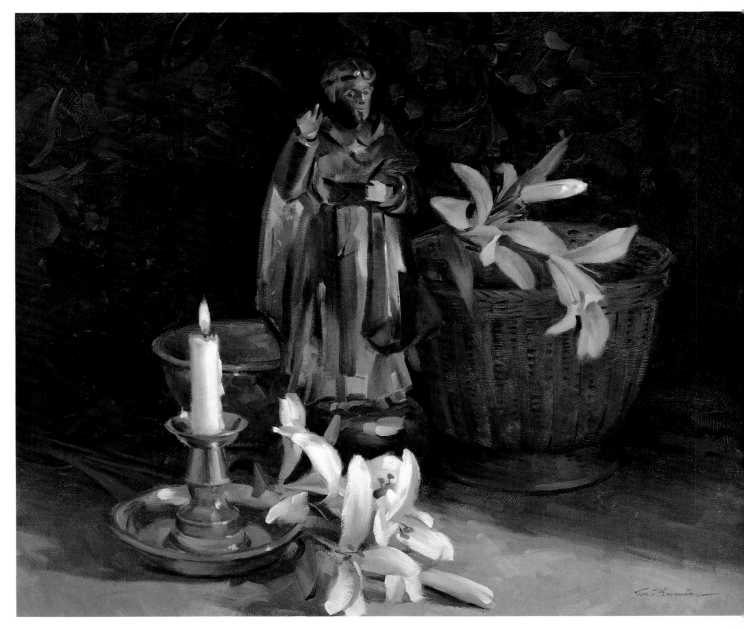

Relic of Religion, *Oil on canvas, 20″ × 24″*

Finish

In this finishing stage, I made adjustments and final touches all over the painting. There wasn't a section of the painting that I didn't analyze and compare to decide whether to fine tune it or leave it alone.

I added more detail to the wooden figure to give it the appearance of painted wood that had been chipped and weathered. I also made a few adjustments in its drawing.

I also refined the flowers a bit more, shifting values here and there. Then, with a small brush, I suggested the straw weaving in the basket. Actually, if you look closely, you can see that it was the *shadows* between the strips that I painted to imply the character of the basket.

As an afterthought I wanted to see how things would look if the candle were lit. After lighting it, I thought it might add an interesting touch, so I

painted in the flame. I looked carefully to see what effect it was having on the other objects. It was minimal, but on the rim of the bowl a touch of orange indicated a reflection of the flame. I could have carried things further, adding more detail and making corrections, but I already felt that a feeling of freshness was beginning to wane. So at that point, I considered the painting finished.

Conclusion

As much as the length of this book has allowed, I have tried to share with you the ideas and principles that have made painting more enjoyable and proficient for me. I hope I've been successful in demonstrating their usefulness. Keep in mind, though, that they reflect ways that I perceive painting. Others have their own opinions about art and their own ways of painting. If any of what I have presented is useful to you, then I feel my efforts have been worthwhile and successful. However, I would like to leave you with a few more thoughts that have had the most dramatic effect on my career as a painter.

If there is one statement that I've pledged to live by in my life as an artist, it is, "You must remain a student." That thought is foremost in my mind every time I prepare a canvas for painting. It's not very often that I'm truly satisfied with a picture I've completed. Although it may have been the best I could do on that given day, I strive to do better on my next one. We should all aspire to work greater than our own. When we feel that we have reached that same level, a higher mark has with all probability already been set. It's the normal process painters go through in their self-imposed struggle to improve.

For me, the most effective way to improve is by painting every day. When I've pinpointed a particular area of the painting process where I feel that I fall short of my own expectations, I start out on a problem-solving quest. I read books, talk to other artists, observe paintings I admire, but most important, I practice.

Years ago I felt I had run into a brick wall, and just couldn't seem to come up with the solutions to some problems I was having. I finally got up the nerve to call a most respected painter and plead my case, hoping for an invitation to his studio. Well, I got the invitation, drove six hundred miles to his home, and in just a few days came away realizing that the answers had always been right in front of me. I simply hadn't been painting from life often enough. Oh, it's not that I had never painted from life before; I had from the beginning. But not with any consistency, and that's what makes the difference.

I know that many artists — students and professionals alike — use the aid of photography to create paintings. I use it myself. But to depend on photographs without the advantage of having done many paintings from life, is a trap that stifles a lot of untapped creativity and self-expression. I just can't stress enough the importance of painting from life often enough to let its benefits spill over and have positive effects on other methods of painting.

Finally, before wishing you good luck on all your future paintings, I'd like to urge you to pass along any information and knowledge you have to anyone asking for your help. As long as the recipient understands that there are no absolute rules for painting, the opportunity to hear enlightening ideas and learn different techniques can open the door to hundreds of possibilities. You might also realize that hearing yourself repeat some of what you understand can reinforce your knowledge as well as boost your own self-confidence. So in closing, remember to practice the basic principles, paint from life often, always remain a student, and be willing to share your knowledge. Good luck and good painting.

INDEX